OPULENT TEXTILES

The Schumacher Collection

Richard E. Slavin III

CROWN PUBLISHERS, INC.
NEW YORK

Published by
Crown Publishers, Inc.,
201 East 50th Street,
New York, New York 10022.
Member of the
Crown Publishing Group.

CROWN is a trademark of
Crown Publishers, Inc.

Manufactured in Japan

Designed by Nancy Kenmore
with Deborah Kerner

Library of Congress
Cataloging-in-Publication Data

Slavin, Richard E.
Opulent textiles:
the Schumacher Collection/
by Richard E. Slavin III.

Includes bibliographical
references and index.

1. F. Schumacher & Co.
2. Textile fabrics—United States—
History—19th century.
3. Textile fabrics—United States—
History—20th century.
I. Title.

NK8998.F2S5 1992
677′.02864′097471—dc20 91-23305
CIP

ISBN 0-517-58255-4
10 9 8 7 6 5 4 3 2 1
First Edition

PRECEDING SPREAD:

SEE Plate 210.

RIGHT: SEE Plate 241.

FABRICS, FURNITURE, COLOR SCHEMES, WHICH HAVE BEEN HANDED TO US THROUGH GENERATIONS AND CENTURIES, WOULD NOT HAVE SURVIVED IF THEY HAD NOT MERIT, WHICH WILL OUTLIVE A GREAT DEAL OF OUR MODERN IDEAS; THERE IS SOMETHING NOBLE IN A FINE CLASSIC FABRIC . . . NOBILITY IS IN THE BLOOD, AND THERE WILL ALWAYS BE ROOM IN GOOD DECORATIONS FOR CLASSIC DAMASKS, BROCADES, AND TAPESTRIES.

Pierre Pozier

JANUARY 1934

CONTENTS

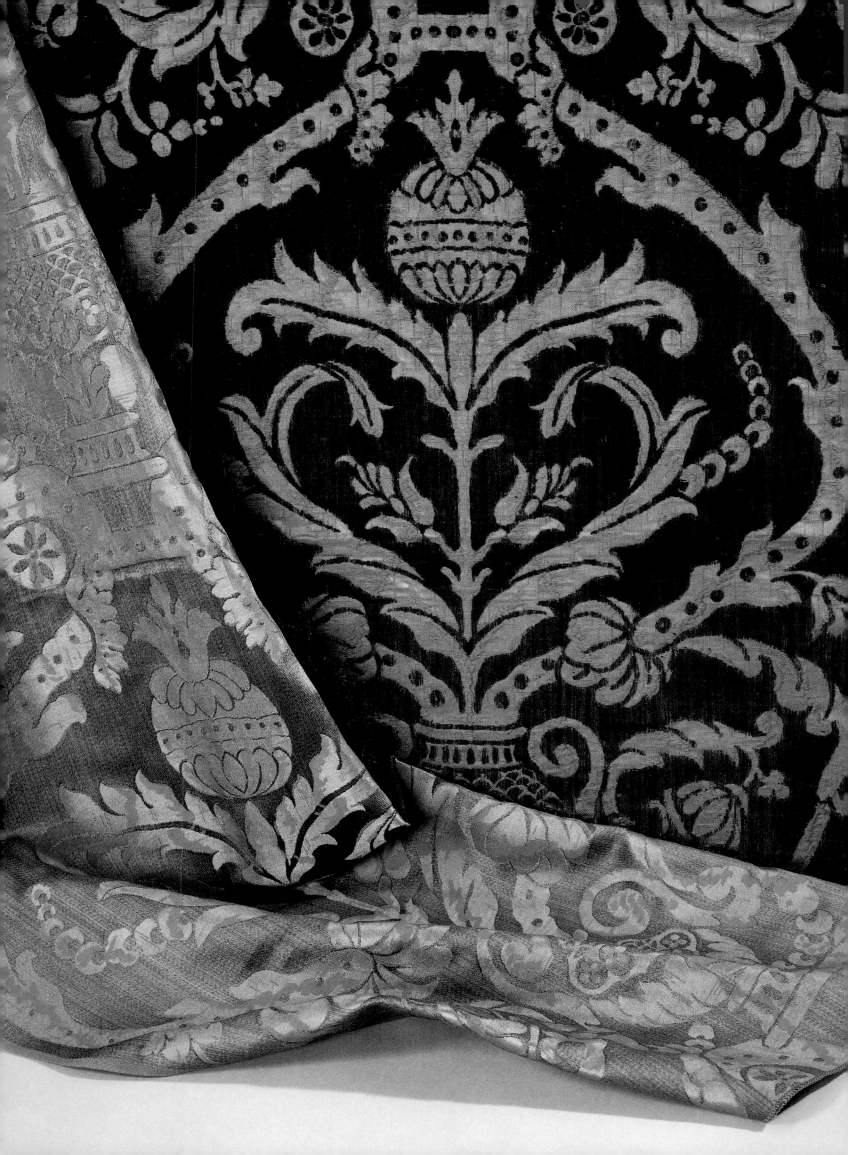

ACKNOWLEDGMENTS

\mathcal{F}or six years, I have had the pleasure of working with the intriguing records and beautiful fabrics that constitute the Schumacher archives. This has been made possible through the interest and generosity of Philip and Gerald Puschel, the Chairman and the President of F. Schumacher & Co. As all books are team efforts, I have had the good fortune to be assisted by curator Phyllis Wickham, who never flinched at the myriad requests with which I bombarded her, and Kathleen Craughwell, who provided curatorial assistance. Rita Davis, who whizzed through the mysteries of the PC, turned my handwritten jumbles into readable copy. I am truly grateful to Robert Herring, who graciously provided the glossary. I am indebted to Lynn Felsher, Julia F. Davis, and Hank Dunlop for their research assistance and advice. These friends pursued specific topics that, because of deadlines and distance, I could not have completed.

The superb photography of the archival textile documents is the work of Lynton Gardiner and Stephen Ogilvy, whose talent and suggestions greatly enhanced our fabrics.

The staff at Schumacher has helped with this project. I would like to thank Nina Aaronson, Jim Baker, Betty Barrow, David Bebon, Mary Frances Benko, Mary Ann Carullo, Ray Chevallier, Cynthia Clark, Karen Clements, Susan Dennison, Janelle Frederking, Patrick Gallegher, Deborah Gallegos, Jim Hinthorn, Dottie Hollinger, Margot Horsey, Vivian Infante, Betty Krzanik,

LEFT: SEE Plate 76.

Dorothy Kupillas, Camille Madonna, Virginia Manoogian, Margot Nappo, Mary Pelak, Brigitte Ple, John Quilter, Mark Saley, Eleanor Swannell, Natalie Tedone, Andrea Toback, Mindy White, Harold Wiener, Robin Williamson, and Ted Wrona.

Equally as interested and helpful were Schumacher retirees Culver Benton, George Berger, Ed Diehl, Fred Elisius, Pierre Freyss, Paul Gadebusch, Margaret Grove, James Hand, Marion Hoffman, Al Hunecke, D. Vernon Jones, Creighton Keating, Art Moebius, and Walter and Françoise Puschel.

Numerous people willingly answered questions, gave advice and information, and provided photographs. My sincerest thanks to Terry Ariano, Linda Baumgarten, Robert and Dorothy Brown, Gail Burger, Joseph Butler, Cindy J. Castenada, Richard Cheek, John Cherol, Edward S. Cooke, Jr., K. Ruth Corcoran, Kaye Crippen, Elaine Dee, Jane Dorchester, Susan Y. Elter, David Fandetta, Henry Groskinsky, Barbara Hall, David A. Hanks, Emily Horner, Craig Jessup, Laura Katz, Robert Kaufman, Ksenya Kebuzinski, Ken Kipps, Bruce Laverty, Phyllis Lee, Karen Lucic, Barbara Barondess MacLean, Don McTernon, Susan Meller, Herbert Mitchell, Betty C. Monkman, Gillian Moss, Thomas Moulin, Richard and Jane Nylander, Anne Odom, Karen L. Otis, Mrs. Leonard J. Panaggio, Susan Pandich, Ronald D. Patkus, Margaret Pritchard, Elbertus Prol, Maureen Quimby, Colvin Randall, Rosanne Sachson, John Schauer, Mary Schoeser, Esther Shaw, Kathy Stocking, Hazel O. Stroda, Christa C. Thurman, Margaret Tramontine, Sarah Vass, Rose Vitzthum, Deborah D. Waters, Jon Williams, Mickey Wright, and Dr. Alice Zrebiec.

Finally, I wish to thank John-Peter Hayden, Jr., without whose guidance, counsel, and encouragement this book would never have been produced.

Right: see Plate 62.

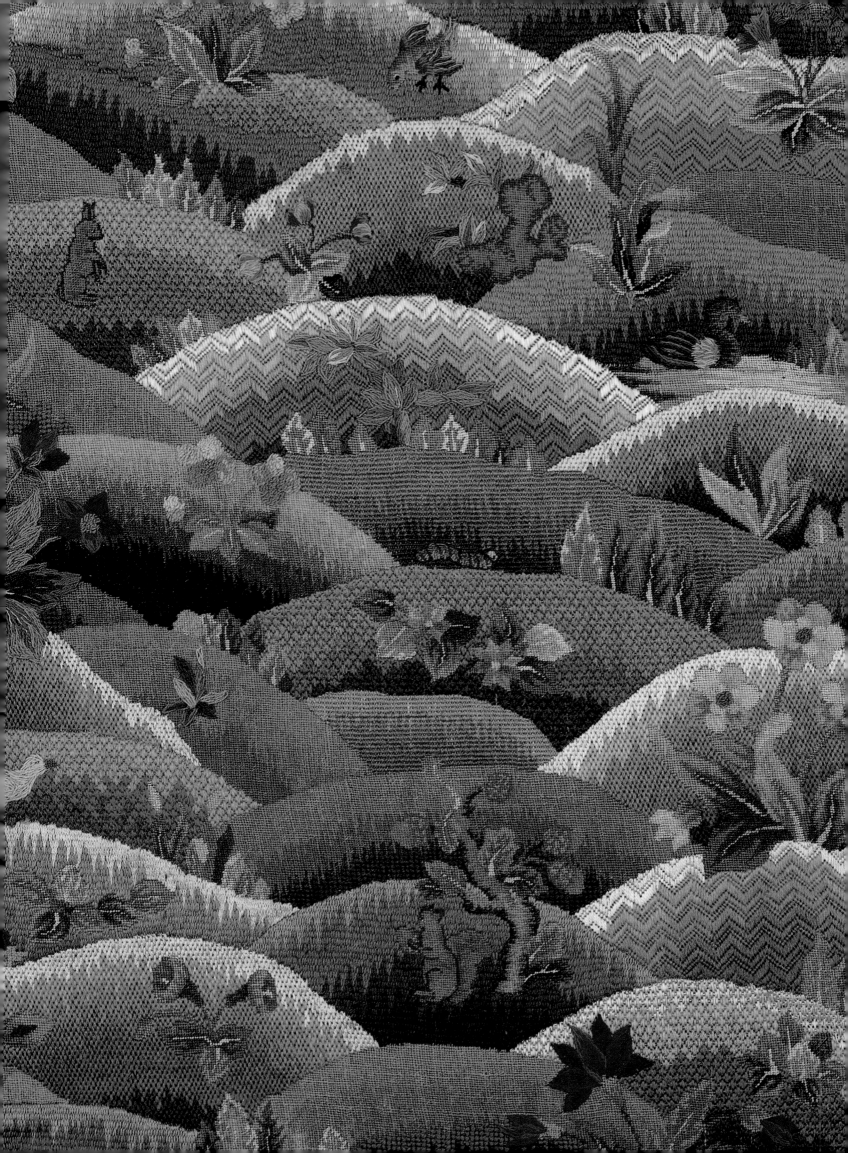

FOREWORD

Since the beginning of the industrial revolution, textile designers and manufacturers have collected illustrated books, prints, wallpapers, embroideries, clothing, and samples of actual printed and woven textiles as inspiration for their designs. In some cases, samples of the same design have been collected and used for inspiration by more than one company. Manufacturers' design collections usually also include samples of their own production.

In the past twenty years, the textile business has evolved in such a way that some manufacturers have come to value these archival collections and to provide them with better storage conditions and to hire trained professionals to sort out, identify, photograph, and catalogue the design sources and production records they contain. The archivists have developed orderly systems of control, and it is now unusual to see historic documents stashed helter-skelter in design studios, public relations files, showrooms, dye houses, weave sheds, and executive offices. At F. Schumacher & Co., the establishment of professional archives management has led also to a desire to share the design history of the firm through the media of exhibition and publication. This volume is the most ambitious effort by an American textile firm to open its holdings to textile scholars and an interested general public. It is perfectly fitting that they should do so, for a review of Schumacher's important role in both traditional and modern textile design throughout the twentieth century provides a history of

LEFT: SEE Plate 180.

American textile design and usage during those years. Still, it is a rare thing for a manufacturer to share its archival collections with the public, for they are rightly concerned with their proprietary rights in original designs. Schumacher's decision to do so through the medium of publication is a happy one indeed.

The preservation of a large portion of the vast Schumacher archives is a remarkable happenstance, for like most industrial archives, there was a time when the value of the samples was not recognized and they were poorly cared for. Fortunately, the importance of the archive was recognized in time for the most significant part to be preserved. Many of the archives of other textile firms have been totally lost when companies changed hands or closed entirely.

It has long been customary in the textile printing industry to mount samples of each new design or dye lot in scrapbooks and to record specific information concerning the fibers, threads, dyes, and mordants used to achieve particular effects. Sample books and cards were also compiled for use in the wholesale trade. Although each of these originally had its proper place in the sequence of the total oeuvre of a particular maker in a particular place and time, few documented long runs of samples have been preserved outside the warehouses and archives of the manufacturers themselves.

Individual examples of weavers' and dyers' books and salesmen's samples have been collected by museums and there are notable examples at Colonial Williamsburg, the Winterthur Museum, the Philadelphia College of Textiles, the Patterson (New Jersey) Historical Society, the Rhode Island School of Design, Old Sturbridge Village, the Museum of American Textile History, the Essex Institute, and some local historical societies. In

England, there are important collections at the Victoria and Albert Museum in London and the City Museum in Manchester. In France, the textile museums at Mulhouse, Lyons, and Paris have significant collections. Selections from these have been published with excellent color illustrations by Florence Montgomery in her dictionary *Textiles in America, 1650–1870* (New York: Norton, 1984) and in "John Holker's Mid-Eighteenth Century 'Livre d'Enchantillons,'" in *Studies in Textile History* (Toronto: Royal Ontario Museum, 1977). Diane Fagan-Affleck has published samples of dress and furnishing fabrics in *Just New from the Mills: Printed Cottons in America, Late Nineteenth and Early Twentieth Centuries* (North Andover, Massachusetts: Museum of American Textile History, 1987). The most important collections of textile samples remained in the hands of manufacturers, however, where they were unavailable to textile scholars.

The late-1970s market demand for well-documented reproduction textiles fostered the acquaintance of manufacturers and designers with museum curators and conservators who expressed concern about the manufacturers' informal collections care, lack of documentation, and poor storage conditions. Museum scholars were often able to help the companies to date pieces in their archives, and continued to push for improved standards of care in the firms themselves. At the same time, textile manufacturers recognized both the intrinsic and financial value of their sample collections as in-house design libraries. Internal demands for accurate information, efficient retrieval systems, collection control, proper storage, and conservation for fragile originals led to the establishment of professionally managed archives in the major firms in the United States, England, and France.

Recognition of the value of the textile documents contained

in corporate archives led in some cases to a desire to use them to promote an interest in historic textiles through exhibitions. These exhibitions, in turn, would stimulate the market for sales of documentary reproductions. At first, this interest was evidenced by occasional displays of historic documents in showrooms or at national sales meetings. Soon after, there were some concerted efforts to develop formal exhibitions and to provide a permanent record of them in well-illustrated publications.

This phase began in 1975 in London with a commemorative exhibition and accompanying catalogue celebrating Liberty & Co., followed in 1981–82 by *A Choice of Design, 1850–1980; Fabrics by Warner & Sons Limited*, which documented an exhibition shown in seven different venues over a period of two years. In 1984, the G. P. & J. Baker Company exhibition of historical documents and samples of its own production was shown at the Victoria and Albert Museum. The exhibition was shared with a broader public through a well-illustrated catalogue, titled *From East to West: Textiles from G. P. & J. Baker*. In 1985, Sanderson celebrated its 125th anniversary with an exhibition of wallpapers and textiles, and a small illustrated catalogue.

In the United States, Lee/Jofa published a review of their firm's history and illustrated its best-selling designs in a centennial publication in 1988. An exhibition celebrating the sixtieth anniversary of Scalamandre was held at the Paley Design Center of the Philadelphia College of Textiles and Science in 1989 where 105 samples from the Scalamandre firm were shown and 22 were illustrated in the accompanying catalogue, *Scalamandre: Preserving America's Textile Heritage, 1929–1989*.

None of these projects has been on the scale of Richard Slavin's work with the Schumacher collection, however. The pro-

fessional cataloging of the Schumacher archives resulted in the handsome exhibition "A Century of Opulent Textiles," which was mounted at the Place des Antiquaires in New York and is now traveling to museum and design showrooms throughout the United States. Samples from the archive were used as sources for Schumacher's Centennial Collection in 1989. These were carefully chosen to represent the wide range of design sources and historical periods represented in the archives. Now this impressive volume documents one hundred years of American taste in interiors as reflected in the production of the Schumacher firm.

Until very recently, textile studies have focused on the period prior to 1900 or on the work of individual designers. Richard Slavin's review of the Schumacher oeuvre documents twentieth-century trends in the marketplace and the design studio, as well as the role of textiles in twentieth-century American interior design. There is clear documentation of the firm's leadership in modern design, innovation in manufacturing techniques, and the use of new materials. The long persistence of traditional designs, predating the Colonial Williamsburg relationship and greatly expanded by the marketing of documented reproductions under a variety of licensing arrangements, is also well documented.

Although the F. Schumacher & Co. archives, like most corporate archives, is open only to its own employees and to academic scholars by special arrangement, we are fortunate to have its treasures shared with us so generally and introduced in such a scholarly way. Here is an important part of American textile and interior design history for the past one hundred years.

JANE C. NYLANDER, DIRECTOR,

SOCIETY FOR THE PRESERVATION

OF NEW ENGLAND ANTIQUITIES

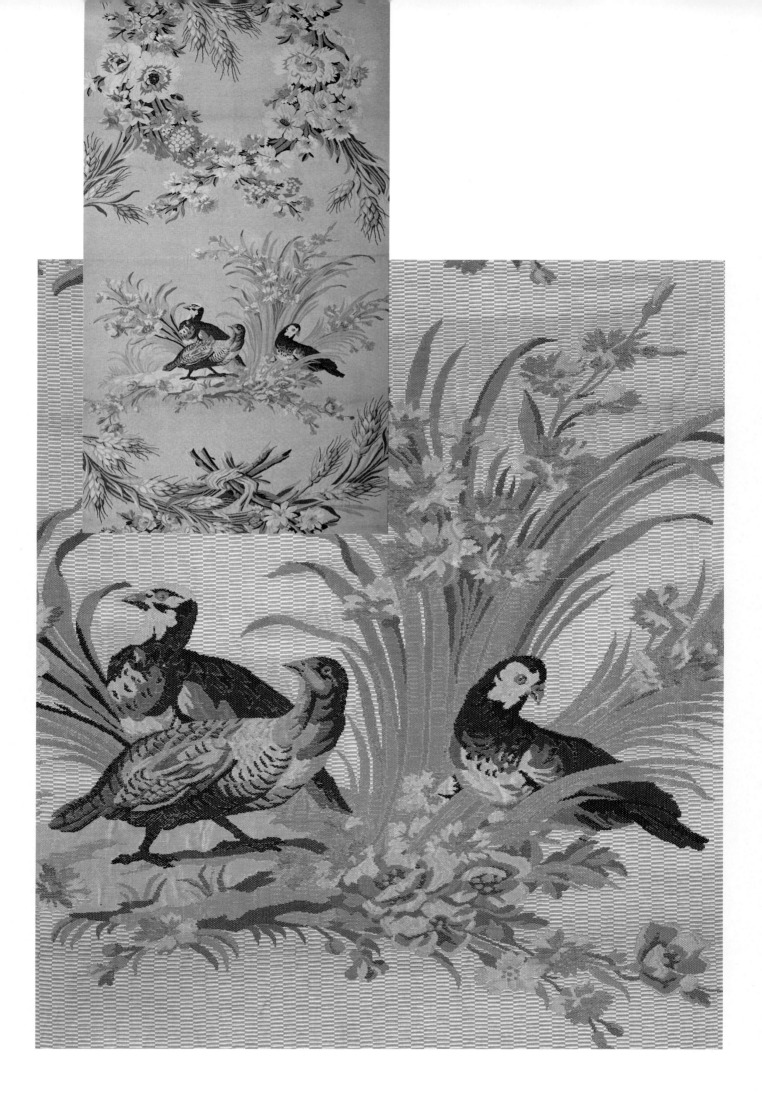

Introduction

Plate 1

This silk brocade panel was described in the earliest review of the Schumacher collection in the publication *The Decorator and Furnisher*, September 1891. The design is a reproduction of an opulent eighteenth-century brocade that Philippe Lasalle, the French genius of silk weaving, created for Empress Catherine the Great of Russia.

Plate 2

In this detail of the brocade, the superb workmanship and painterly quality of the weaving reveals the reason that Lasalle earned the sobriquet "The Raphael of Silk." The use of a striped repp silk background provides a rich surface upon which the quail and flowers appear to float. (The approximate repeat—hereafter, a.r.—of the design is 44½".)

"*I* beg to inform you that I have bought of Messrs. Passavant and Company their entire stock of upholstery goods; and shall on the first of August transfer it under my own name and for my own account." With this simple announcement of 1889, Frederic Schumacher founded his textile establishment in New York at Broadway and Twenty-second Street in the area know as "Ladies' Mile." In just a few years, it would become one of the United States' premier companies providing luxury decorative textiles.

Mr. Schumacher, a sophisticated Parisian conversant in several languages, was equally at home with the architect/decorator clientele in both Europe and the United States. In his early adulthood, he had been in the employ of Vanoutryve, the oldest and largest silk mill in his native France. Prior to founding his own firm, he managed the New York upholstery and drapery fabrics department of Passavant and Company. In remembering Schumacher, a friend wrote, "I simply cannot put in words the charm this man had. His consummate humor was so infectious that people just hated to leave his presence." If one is going to launch a new enterprise, qualities of this sort are obviously an advantage. His witty and urbane manner aside, what really aided Schumacher's success was his sophisticated taste in textiles and his keen business acumen.

Schumacher proved his ability as a shrewd judge of men. In 1893, he took on a young financial partner, Paul Gadebusch, who

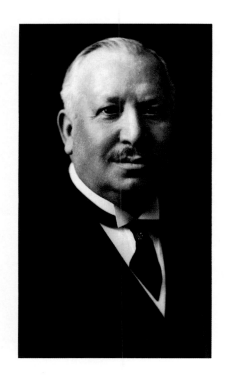

soon made himself invaluable in the daily management and administration of the new firm. Since Schumacher spent a part of each year in Europe to procure the textiles that established the firm's reputation, it was essential that the company operate with well-oiled efficiency while he was abroad. Paul Gadebusch saw to this with dedication. The partnership worked well. Gadebusch was remembered by a colleague as "a father to everyone of the younger members of the organization who always kept his door open to the lowest as well as the highest."

The partners created a triumvirate when they brought Mr. Schumacher's nephew, Pierre Pozier, to the United States to join

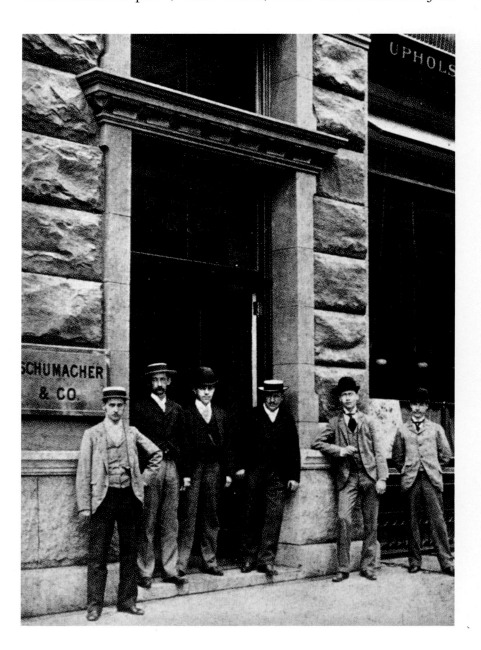

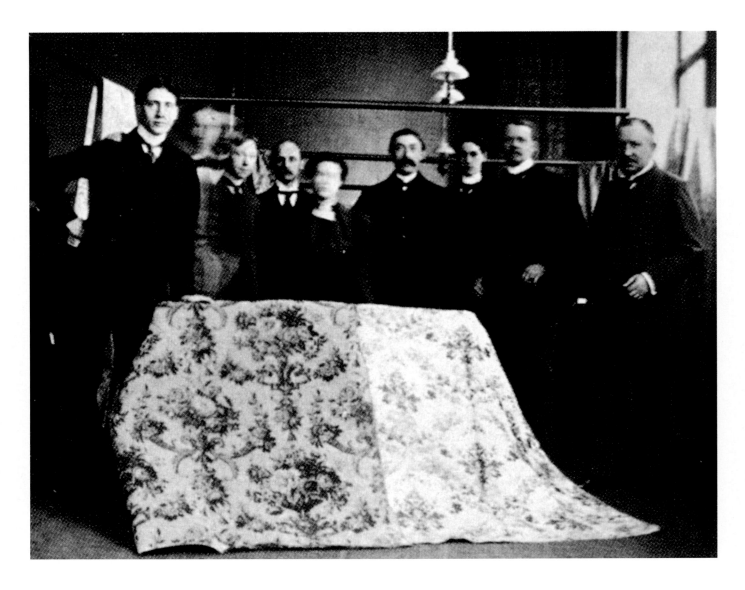

the firm in 1899. A talented painter with a connoisseur's unerring eye and a remarkable ability to anticipate future trends, Pozier created a number of exquisite designs in stunning colors during his lifelong career at F. Schumacher & Co. Like his uncle, he spent a period of each year in Europe. He soon built a reputation for shrewd innovations when he introduced Art Moderne fabrics and designer textiles to the line. Pozier never lost sight of the fact that the firm's reputation was based on its traditional collection, and he knew the value of promotion. In an address to the staff, he stated, "Now and then a more extreme pattern, extreme either in design, in color, or in price, may be added [to the line]. The object of that addition being advertising, maintenance of prestige acquired in many years, rather than a purely commercial aim."

Plate 5

AN 1899 PHOTOGRAPH FEATURES THE F. SCHUMACHER & CO. SHOWROOM WITH THE STAFF AND, ON THE RIGHT, MESSRS. GADEBUSCH AND SCHUMACHER.

It was no accident that the partners developed F. Schumacher & Co. into a standard-bearer for both imported and domestic home-furnishing textiles. With a superb collection of woven and printed fabric designs, perfected over the centuries by European mills, to the newest contemporary textiles, be it Art Nouveau, Art Moderne, or postwar designer fabrics, the company Frederic Schumacher established over a century ago has made a distinguished imprint upon this nation's interior spaces. The uninterrupted operation of its own domestic mill has been an asset on many occasions during national crisis when imports were affected by tariff disputes and the two world wars. Then the company contributed to the nation's war efforts with textiles for the military.

Schumacher has been at the forefront of trends in the textile trade since its founding and has pioneered numerous experiments that later became part of American decorative textile history. Contract textiles, experimental weaves and synthetic yarns, designer fabrics, coordinated collections (fabrics, wallpapers, and carpets), and authentic historic reproductions are a few of these innovative ventures. As a lasting legacy to celebrate its centennial in 1989, Schumacher established archives to preserve its sizable collection of textile documents. The history of the firm represents the history of the decorative textile business in this country. Comprised of antique and Schumacher/Waverly fabrics numbering nearly ten thousand textile documents, this archival collection is a valuable resource to the historian as well as to the designer. The textiles in the archives reflect the taste and also the experiments in decorative fabrics that have transpired over the last one hundred years. Represented in this collection are opulent silks from the Gilded Age, historically inspired fabrics from the country-house eras, shimmering Moderne creations from the Roaring Twenties,

Plate 6

This silk and tinsel brocade, c. 1890, is a design in the eighteenth-century style of Louis XV. It is typical of the sumptuous European silks so prized in the United States during the Gilded Age, when Mr. Schumacher founded his company. (A.R. 27")

OPULENT TEXTILES

26

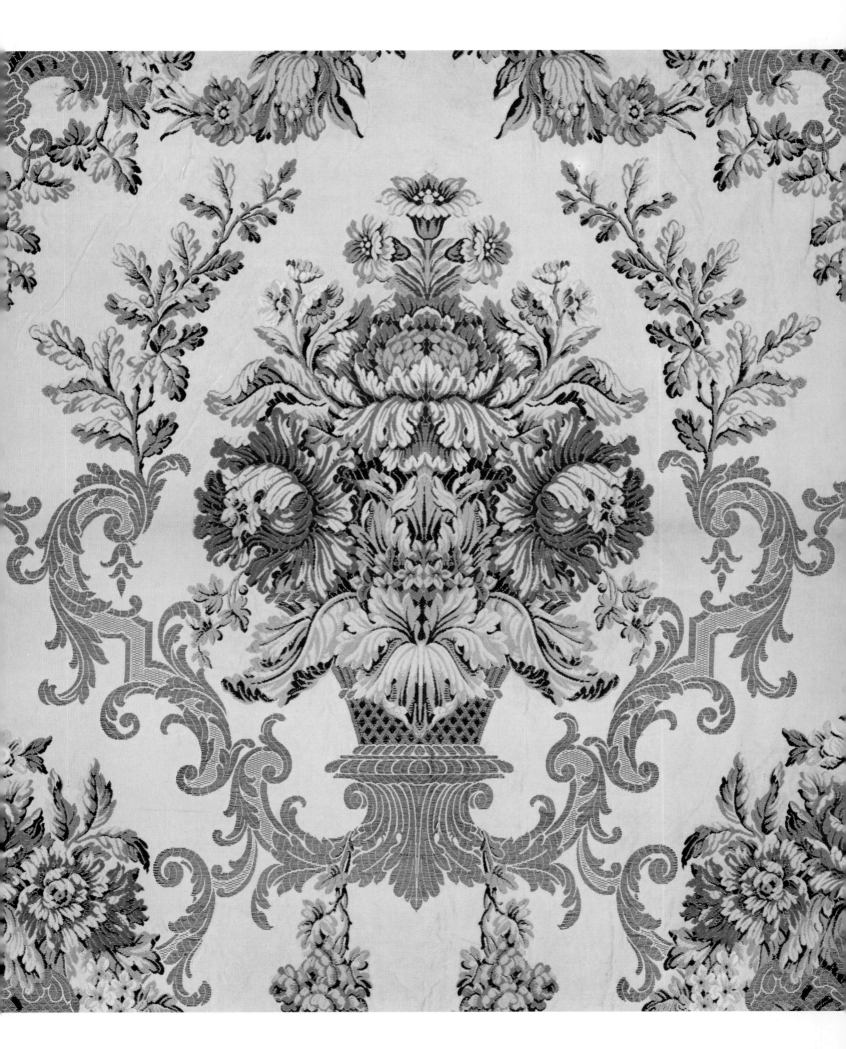

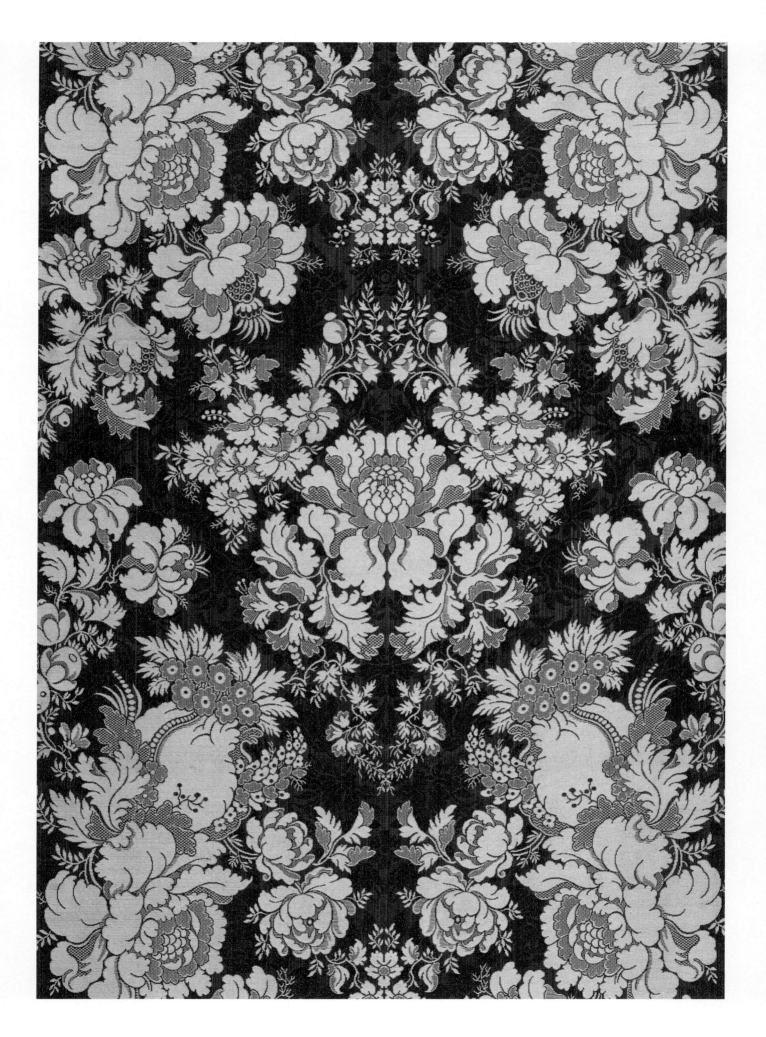

Plate 7

\mathcal{T}HIS SILK DAMASK, C. 1900, *LEFT*, IS AN ESPECIALLY RICH DESIGN IN THE EIGHTEENTH-CENTURY STYLE OF LOUIS XV. ANTIQUE EIGHTEENTH-CENTURY DOCUMENTS FOR THIS DESIGN EXIST IN BOTH THE SCHUMACHER ARCHIVES AND THE COLONIAL WILLIAMSBURG FOUNDATION. THE ORIGINAL DESIGN IS ONE-HALF THE SCALE OF THIS REPRODUCTION. (A.R. 25½″)

Plate 8

\mathcal{T}HE INSPIRATION FOR THIS 1895 WARP-PRINTED SILK, *RIGHT*, IS ANOTHER BROCADE DESIGN BY PHILIPPE LASALLE FOR CATHERINE THE GREAT. THIS PARTICULAR FABRIC WAS CHOSEN BY THE COOPER-HEWITT FAMILY FOR USE ON THE FURNITURE AND IN THE WINDOW TREATMENTS OF THE FRENCH DRAWING ROOM OF THEIR COUNTRY ESTATE, RINGWOOD MANOR, IN NORTHERN NEW JERSEY. (A.R. 33″)

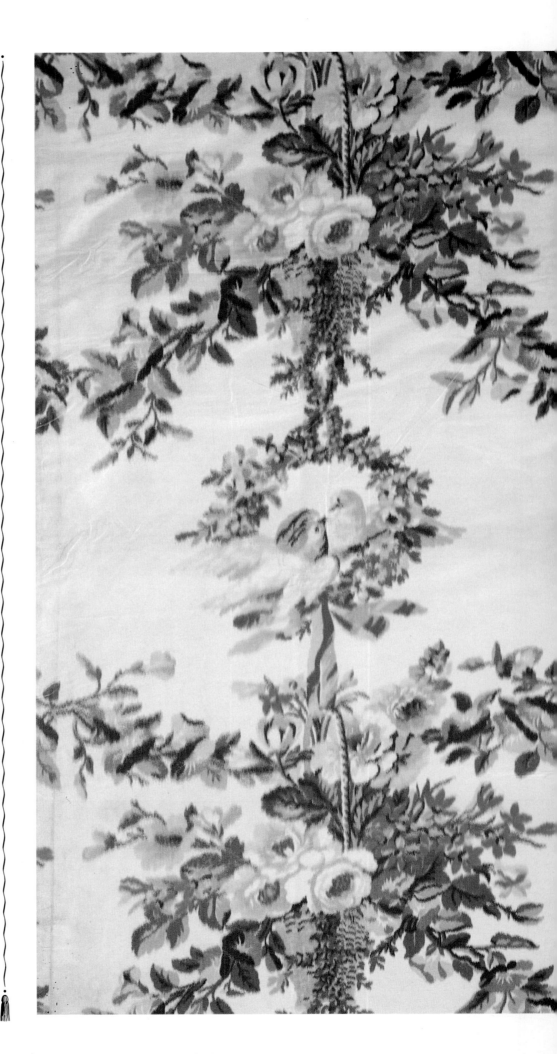

artistic prints by designers from the fifties and sixties, and authentic museum-reproduction textiles from the last fifty years. Technological developments are also represented in examples of textiles ranging from the traditional silk, cotton, linen, and wool to new man-made fibers such as rayon, nylon, Fiberglass, and the recently produced micromattique fabrics.

Supporting the Schumacher textile collection are company records, photographs, ephemera, and a small library. The preservation of these archives and their establishment as a working facility for F. Schumacher & Co. illustrate the firm's continuing pioneer spirit. Until recently, this treasure trove was virtually unknown to anyone outside the company. This book will introduce the comprehensive Schumacher collection to all those who appreciate decorative textiles.

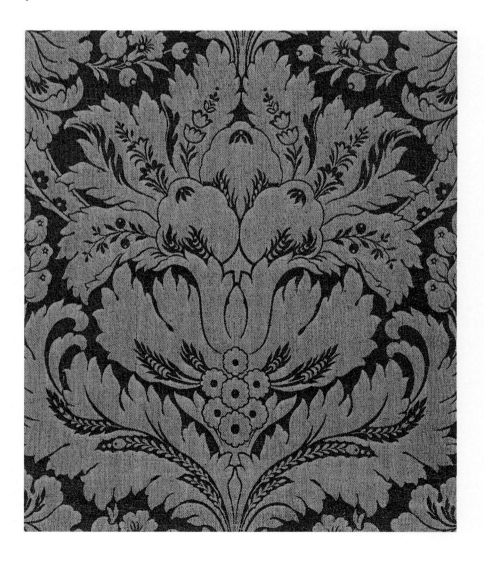

Plate 11

From the Art Moderne collection, this rayon damask stripe of 1924, *left*, epitomizes the modern style with its use of exotic motifs and metallic coloring. With the introduction of its modern collection during the twenties, the firm committed itself to offering a selection of contemporary fabrics as an alternative to the traditional line. (A.R. 22½″)

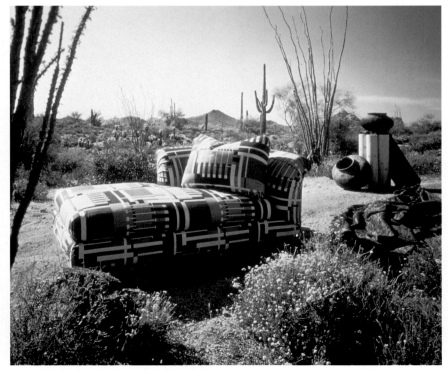

Plate 12

Design 102 is a printed linen of 1987 from the Frank Lloyd Wright Collection, photographed here in the Arizona desert, *left*. The pattern is a current reproduction of the same design from the 1955 Taliesin Line of Frank Lloyd Wright —one of Schumacher's most important designer collections. (A.R. 27″)

Fabrics for the Carriage Trade

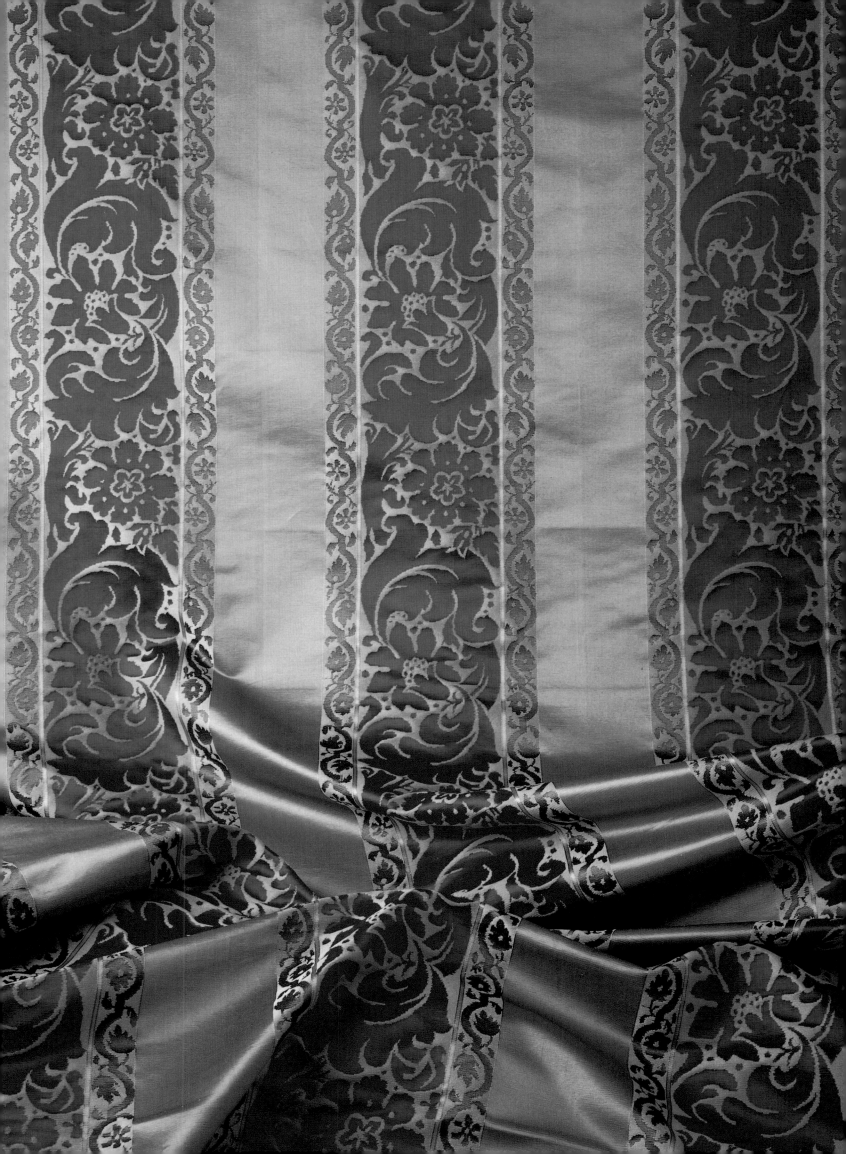

Plate 13

VALENCIA, A SILK AND COTTON
DAMASK STRIPE OF 1991, IS A CON-
TEMPORARY VERSION OF A 1920S DE-
SIGN THAT WAS MADE FOR THE SPAN-
ISH COLONIAL REVIVAL STYLE OF
ARCHITECTURE. THE ORIGINAL
SOURCE FOR THESE DAMASKS IS AN
EARLY EIGHTEENTH-CENTURY SPAN-
ISH LAMPAS IN THE COMPANY'S AR-
CHIVES. (A.R. 14½")

The American Gilded Age reached full-flower during the Gay Nine-ties, just after Frederic Schumacher founded his company in 1889. It was the age when high society reigned supreme as this nation's tastemaker. Customers valued decorative textiles of the finest Euro-pean designs that could be procured—and money was no object. Mr. Schumacher anticipated the needs of the carriage-trade market (an Anglo-American period term for millionaires—referring to those wealthy enough to afford a stable with carriages, horses, and the staff necessary to maintain them). He imported the most expensive luxury fabrics—brocades of the richest silks and tinsel, tapestries in classic Aubusson designs, princely velvets, and opulent silk damasks suit-able for the most formal interior. His first clients were the prestigious architects and decorators who lavished their talents and their clients' money on the great mansions of New York and Newport, and on the grand hotels of that era.

The look of F. Schumacher & Co. was based on classic designs. An early company statement read, "Fabrics, furniture, color schemes, which have been handed to us through generations and centuries, would not have survived if they had not had merit. There will al-ways be room in good decorations for classic damasks, brocades, and tapestries, provided people can afford them." Although the firm's offerings today encompass a wide array of fabrics, carpets, and wall coverings usually less costly than those featured in its early history, its emphasis on quality and traditional design has remained unfaltering.

Of all the textiles in the early Schumacher collection, none was more sumptuous than the brilliantly colored, weighty silk brocades. The splendor of these costliest of fabrics gave the best "show" to the rooms they graced. For centuries, brocades such as those imported by Mr. Schumacher had been featured on the walls and furniture of European mansions and palaces. The United States' new monied ar-istocracy perceived themselves the equal of the Old World's aristoc-racy, and eagerly sought these silks for the historic associations that accompanied the designs. When the Vanderbilts bought a brocade that had originally been designed for Queen Marie Antoinette or the Empress Catherine the Great, you can be certain that they expected their peers and the popular press to make the connection.

The trade publication *Decorator and Furnisher* reported in Sep-tember of 1891, "Mr. Schumacher is a large importer of the choicest upholstery and drapery fabric. . . . He has a large supply of silk tapes-tries (brocades) in Louis XV and Louis XVI suitable for the finest

PRECEDING SPREAD:

SEE Plate 26.

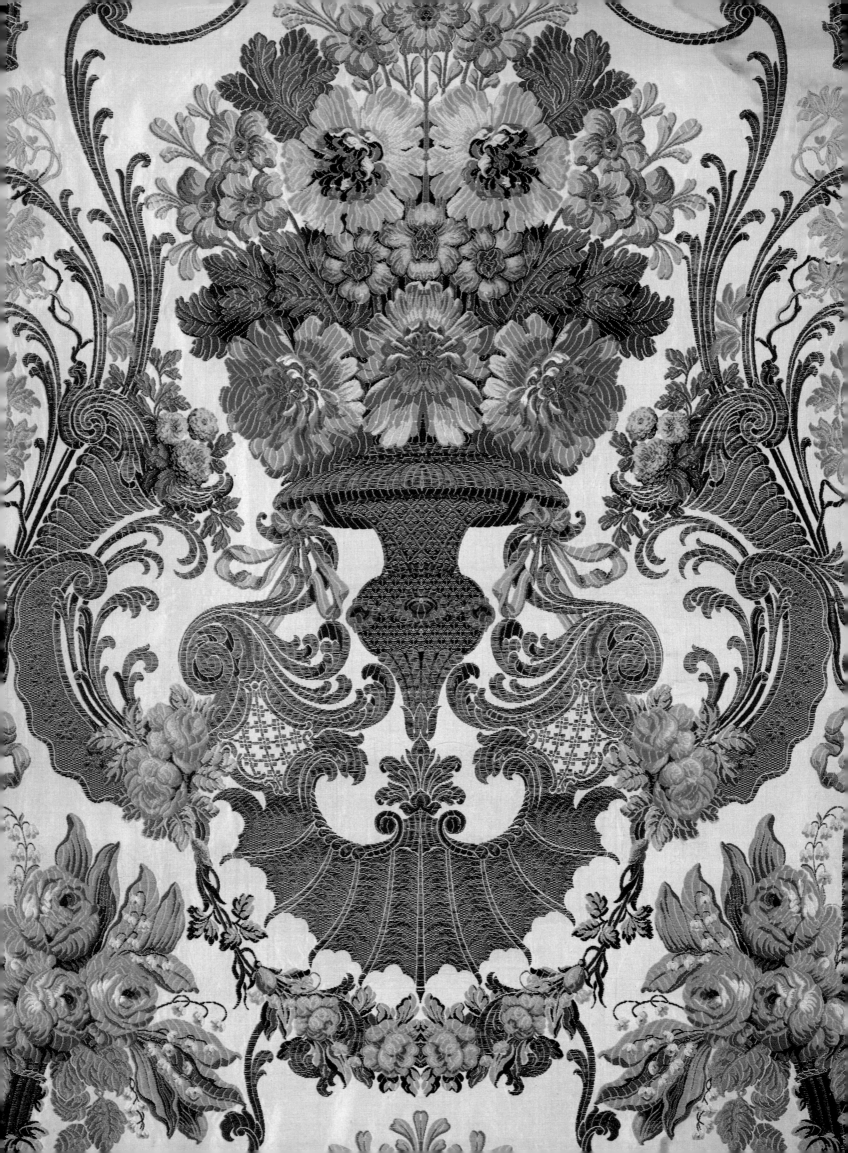

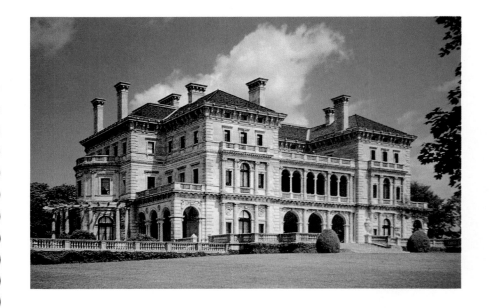

Plate 14

THE BREAKERS, *RIGHT*, IS THE
NEWPORT SEASIDE COTTAGE BUILT
BY RICHARD MORRIS HUNT FOR COR-
NELIUS VANDERBILT II IN 1893—95
(PHOTOGRAPH, 1988). SCHUMACHER
PROVIDED FABRICS IN THE FRENCH
STYLES FOR THE FAMILY QUARTERS
DECORATED BY OGDEN CODMAN.

Plate 15

THIS SUMPTUOUS SILK AND TINSEL
BROCADE, C. 1890, *LEFT*, IS WITHOUT
QUESTION THE FINEST GILDED AGE
BROCADE IN THE SCHUMACHER AR-
CHIVES. THE RICHNESS OF THE SILK,
THE ARTISTRY OF EXECUTION, AND
THE OPULENCE OF THE DESIGN ALL
CONTRIBUTE TO THE BEAUTY OF THIS
ELEGANT AND EXPENSIVE TEXTILE.
LUXURIOUS SILKS OF THIS TYPE
WERE OFTEN STRETCHED ON THE
WALLS OF A PALACE OR MANSION.
(A.R. 33″)

Plate 16

THIS 1898 PHOTOGRAPH OF THE
WALDORF-ASTORIA HOTEL, *RIGHT,*
LOOKS NORTH ON FIFTH AVENUE.
SCHUMACHER FABRICS GRACED THE
DINING ROOM OF THE WALDORF AND
NUMEROUS MANSIONS ALONG THIS
AVENUE OF GILDED AGE BUILDINGS.

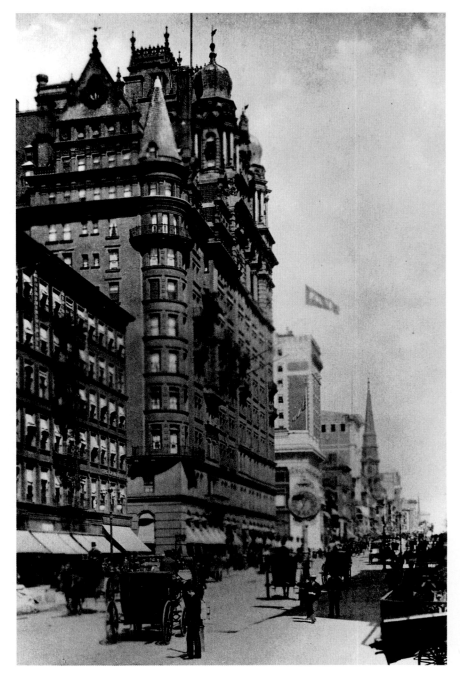

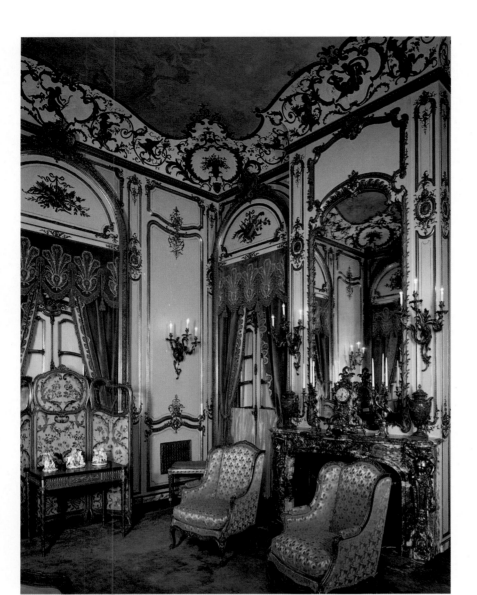

decorative trade. . . . There are magnificent patterns in brocatelles and brocades, and in broche weaves. . . . Decorators in search of fabrics that are at once artistic and fashionable, should not fail to inspect the beautiful line of goods imported by Mr. Schumacher." This is an impressive review for a firm barely two years old. The company's quality fabrics were soon on display from New York to San Francisco in the mansions of the Vanderbilts, Roosevelts, and Floods.

With firms such as McKim, Mead & White, Herter Brothers, L. Marcotte & Co., Tiffany Studios, Richard Morris Hunt, and Ogden Codman as customers, Frederic Schumacher's textile house made a distinguished imprint upon American interior decoration. By 1901, the company had offices in Boston, Philadelphia, and Chicago; its salesmen traveled to the West Coast and all through the South. Schumacher was working constantly to provide new designs for his clientele. He wrote to his partner from France in 1894, "We have to make more efforts than an old established house. I think, however, that

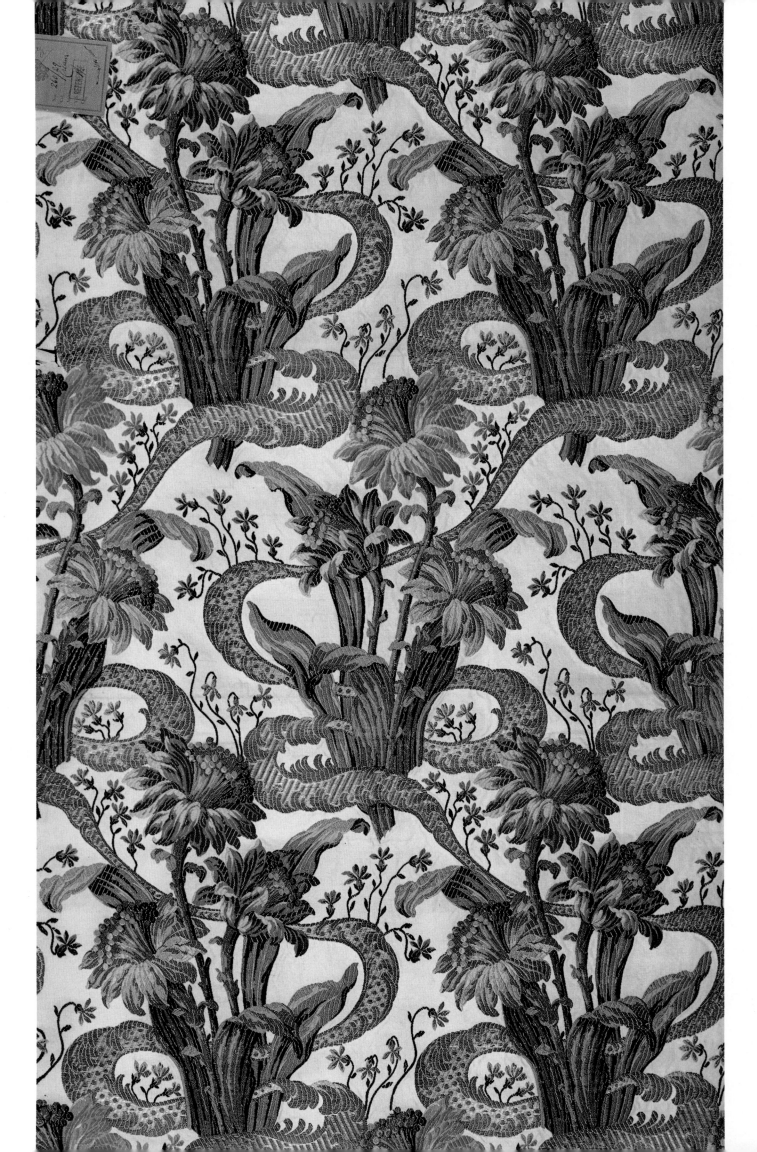

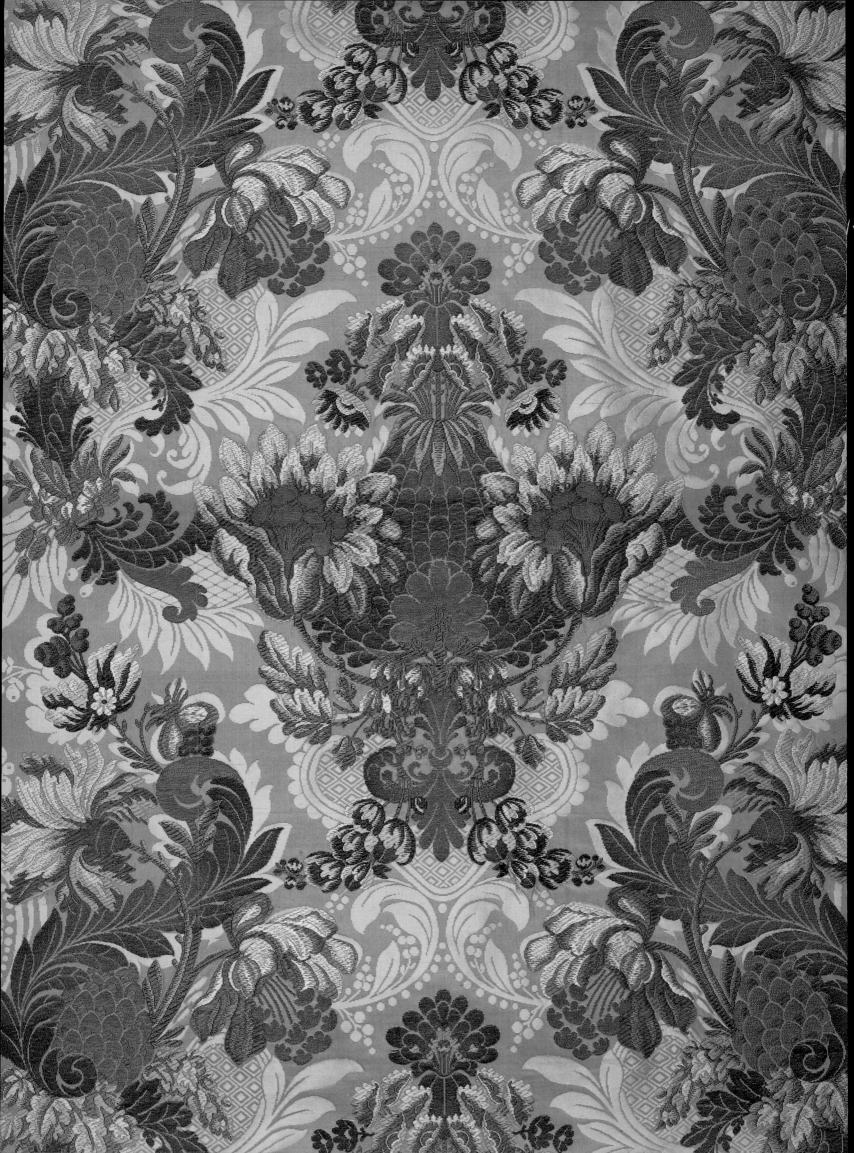

Plate 19

This brocade of silk and tinsel, c. 1890, *LEFT*, is a most luxurious fabric in the early-eighteenth-century Baroque style of Louis XIV. The gold-on-gold ground provides a rich backdrop for the colored silk and metallic yarns. (A.R. 17¼″)

you will be satisfied with our line, and that, in these hard times, we will create somewhat of a sensation by having a nice assortment of novelties to show while others have scarcely anything."

Although F. Schumacher & Co., was founded as an import house of fine European textiles, the McKinley Tariff Act of 1890 and the panic of 1893 encouraged Frederic Schumacher to look to the United States for resources. Schumacher and financial partner, Paul Gadebusch, opened their own American silk weaving mill in Paterson, New Jersey, in 1895. Known as "Silk City," Patterson was home to a large population of French immigrant weavers. Highly skilled and intimately acquainted with European weaving methods and standards, these workers—many from the noted silk-weaving city of Lyons—soon produced fabrics indistinguishable from the firm's imports.

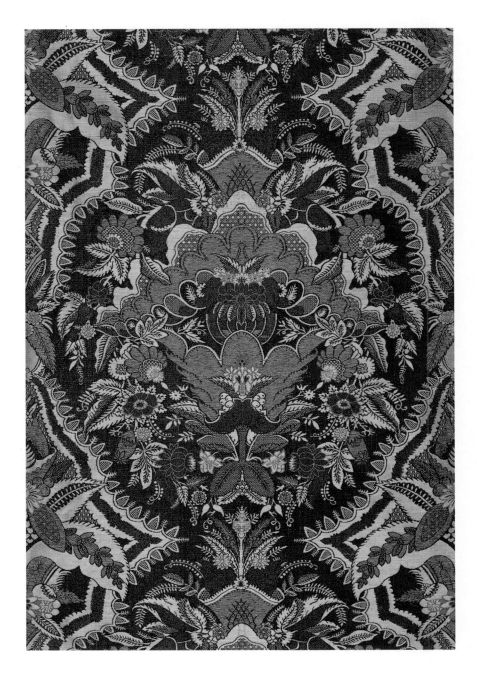

Plate 20

This silk and tinsel brocade, c. 1890, *RIGHT*, is known as a lace pattern because it was inspired by antique lace designs. The richly colored fabric is in the Baroque style and coloring of Louis XIV. (A.R. 20¾″)

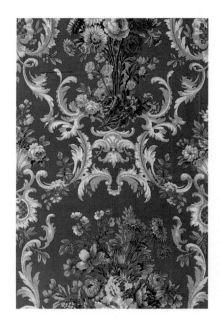

Plate 21

\mathcal{A} SILK BROCADE PANEL, C. 1895, *ABOVE*, OF FLORAL BOUQUETS IS ENFRAMED IN SCROLLS AND RO-CAILLE IN THE EIGHTEENTH-CENTU-RY STYLE OF LOUIS XV. PANELS OF THIS TYPE WERE USED FOR UPHOL-STERY, WITH THE DESIGNS CEN-TERED ON CHAIR AND SOFA BACKS AND SEATS.

Plate 22

\mathcal{T}HIS ELEGANT BIZARRE PATTERN SILK AND TINSEL BROCADE, C. 1915, *RIGHT*, IS DESIGNED AFTER THE EX-OTIC ORIENTAL-INFLUENCED ITALIAN SILKS OF THE LATE SEVENTEENTH CENTURY. THE PALETTE IN THE YARNS, HOWEVER, IS MORE CLOSELY ALLIED WITH THE COLORS FAVORED BY THE FAUVES OF THE EARLY TWEN-TIETH CENTURY THAN COLORS GEN-ERALLY USED IN THE LATE 1600S. (A.R. 25½")

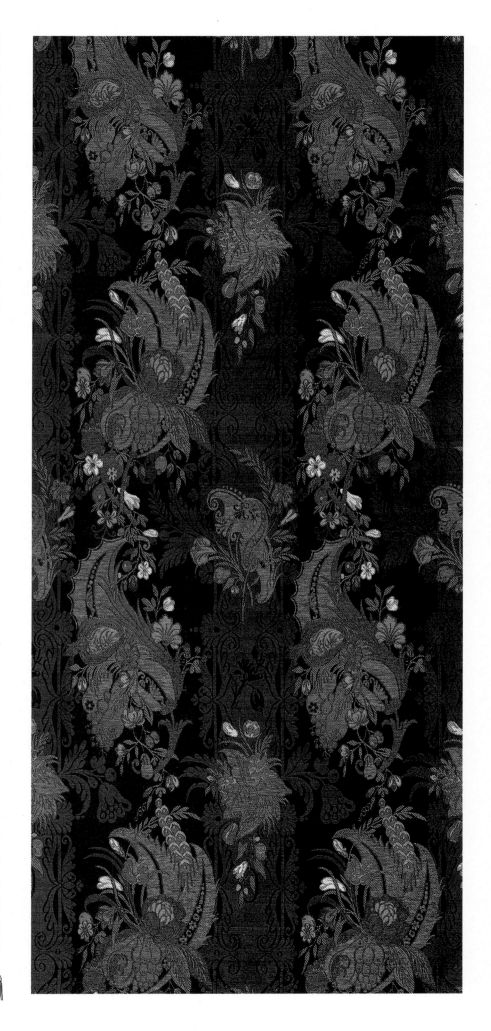

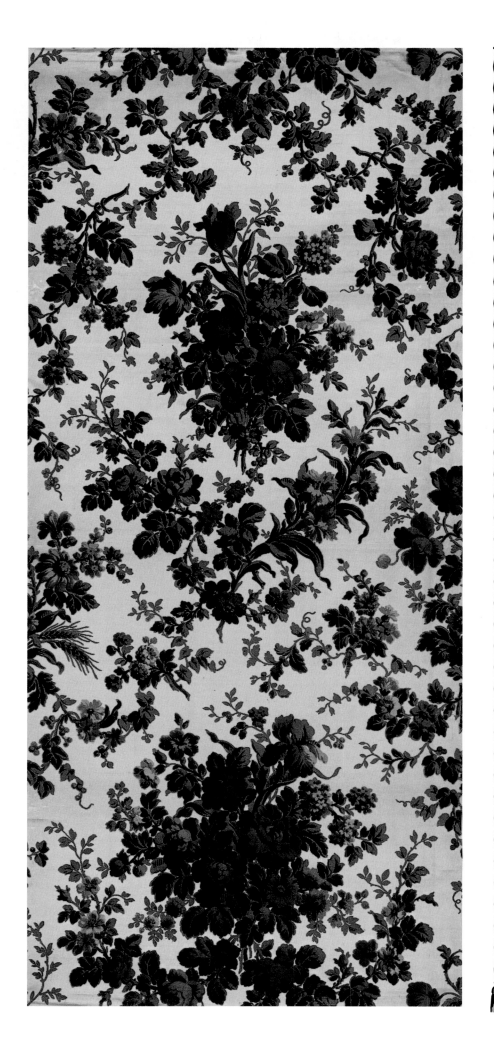

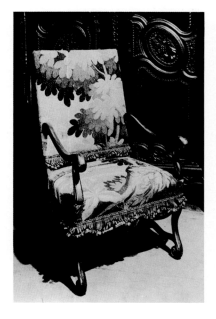

Plate 23

THE WOOL TAPESTRY SHOWN HERE, C. 1915, *ABOVE*, IS TYPICAL OF THE LARGE SELECTION OF AUBUSSONS IN THE SCHUMACHER LINE DURING THE EARLY DECADES OF THE COMPANY'S EXISTENCE. THE GREEN FOLIAGE, OR VERDURE-STYLE TAPESTRY, WAS TYPICAL OF THE SEVENTEENTH CENTURY. THE CHAIR, ALSO A REPRODUCTION, IS KNOWN AS THE ST. CLOUD PATTERN BY PALMER AND EUBURY.

Plate 24

PERFECTLY SUITED TO THE GRANDEST GILDED AGE INTERIOR, THIS LUSH VOIDED VELVET ON A SATIN GROUND, C. 1900, *LEFT*, IS A NATURALISTIC LOUIS XV DESIGN, SCALED DOWN FOR USE AS UPHOLSTERY. (A.R. 54″)

Although the mill products were only a minor portion of the total line, it is from this body of work that Schumacher's most significant contributions have been made. Custom-ordered lampases, brocatelles, damasks, and plain weaves were produced in traditional designs with a speed that gave the firm an edge on much of the competition. The classic designs that are an integral part of the Schumacher reputation were often of eighteenth-century derivation. Sources for the creation of these designs have varied from the imported designs in the Schumacher collection, antique documents in its archives, museum documents, artworks, and books.

With the development of its own weave for an all-silk organzine damask for walls and theater curtains, the company quickly added theaters and opera houses to the mill's list of special-order clients.

Plate 25

Preceding spread: THESE WOVEN
AND PRINTED BORDERS, C. 1900,
ARE FOR FURNITURE, DRAPERIES,
AND WALLS. *TOP, LEFT TO RIGHT:*
SILK AND TINSEL BROCADE (A.R.
6½"); SILK BROCADE (A.R. 17½");
SILK DAMASK (A.R. 13¾"); PRINTED
COTTON TWILL (A.R. 24"). *BOTTOM,
LEFT TO RIGHT:* SILK BROCADE (A.R.
26"); SILK EMBROIDERED SATIN
PANEL (A.R. 13") MEANT FOR BED

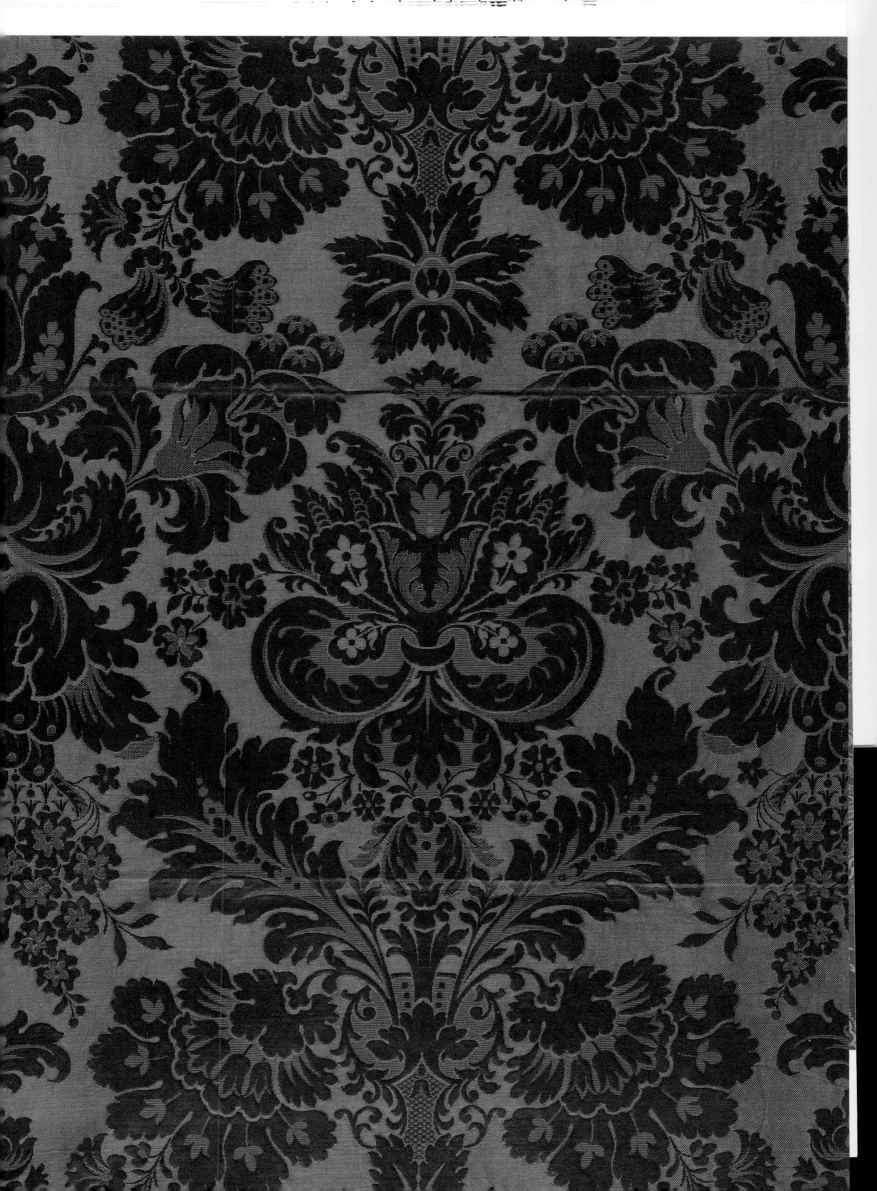

Another long-lived and popular design is the Louis XIV–style
damask, pattern 354, that has been in the line since 1902. Today, this
design is identified in the Williamsburg Fabric Reproductions as
Williamsburg Pomegranate. This regal damask was produced in
blue and gold for the new U.S. Supreme Court Building that opened
in 1935. The design of stylized leaves and pomegranate was repro-
duced from early-eighteenth-century documents that survive in both
the Williamsburg and Schumacher collections. Like Bruton Damask,
this fabric is of an ideal scale for multiple use.

Frederic Schumacher, though ever dedicated to establishing his
company's reputation as a house of traditional fabric styles, was al-
ways abreast of new trends and fashions in the textile arts. For exam-
ple, Schumacher appreciated the great designs of his day, recognizing
the genius and beauty of the modern designs of the Art Nouveau

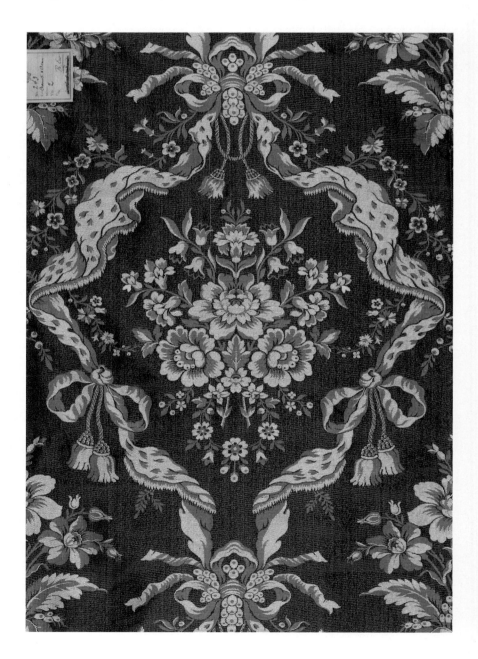

Plate 35

In the master bedroom of the M. H. deYoung's town house at 1919 California Street in San Francisco, the damask used on the walls, windows, and bed canopy is believed to be from Schumacher (photo by Gabriel Moulin, San Francisco, 1920).

Plate 36

A silk damask, c. 1902, is a favorite Louis XIV design. This pattern, OPPOSITE, based on an eighteenth-century silk damask document, has been in the line at Schumacher almost as long as pattern 162. Today this design is part of the Williamsburg Fabric Reproductions by Schumacher and is currently known as Williamsburg Pomegranate Damask. This colorway dates from 1924 and was illustrated in a color advertisement and company book of that year. (A.R. 34½")

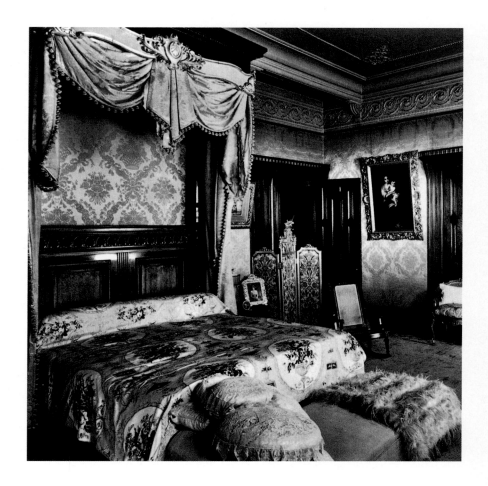

movement. He accepted a number of Art Nouveau designs into his line. The motifs relied primarily on sinuous, curvilinear lines and stylized plant forms that at times achieved erotic implications.

Art Nouveau was a daring and provocative style that was perfectly suited to its era during Europe's Belle Epoque and America's Gilded Age. The architecture, furniture, textiles, and decorative arts of this movement were essentially expensive-to-produce luxury items, made for wealthy clients. Although this style never achieved widespread popularity in the United States, the fabrics were perfectly in keeping with Schumacher's emphasis on high-quality products.

After the Paris Exposition Universalle of 1900, the firm offered a small selection of Art Nouveau fabrics. Schumacher based its choices of designs on quality and elegance. The Art Nouveau line included Rose Topiary and Phoenix Birds, a brocade of silk and tinsel; Ombelliferes, a brocaded silk velvet; and Panneau Coronne, a silk lampas (the latter was exhibited at the exposition).

With the debut of the Art Nouveau group, Frederic Schumacher made it clear that the company would make a determined effort in the coming years to include modern designs as an alternative to traditional ones. These modern designs would always match the traditional ones in quality of design and manufacturing.

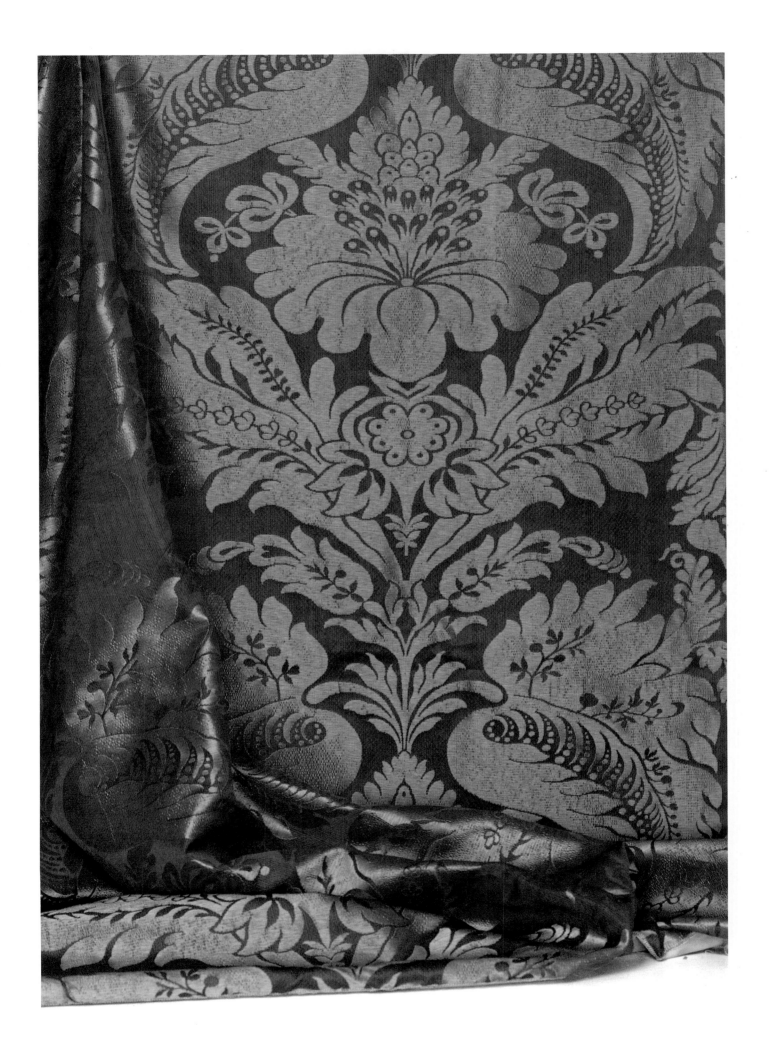

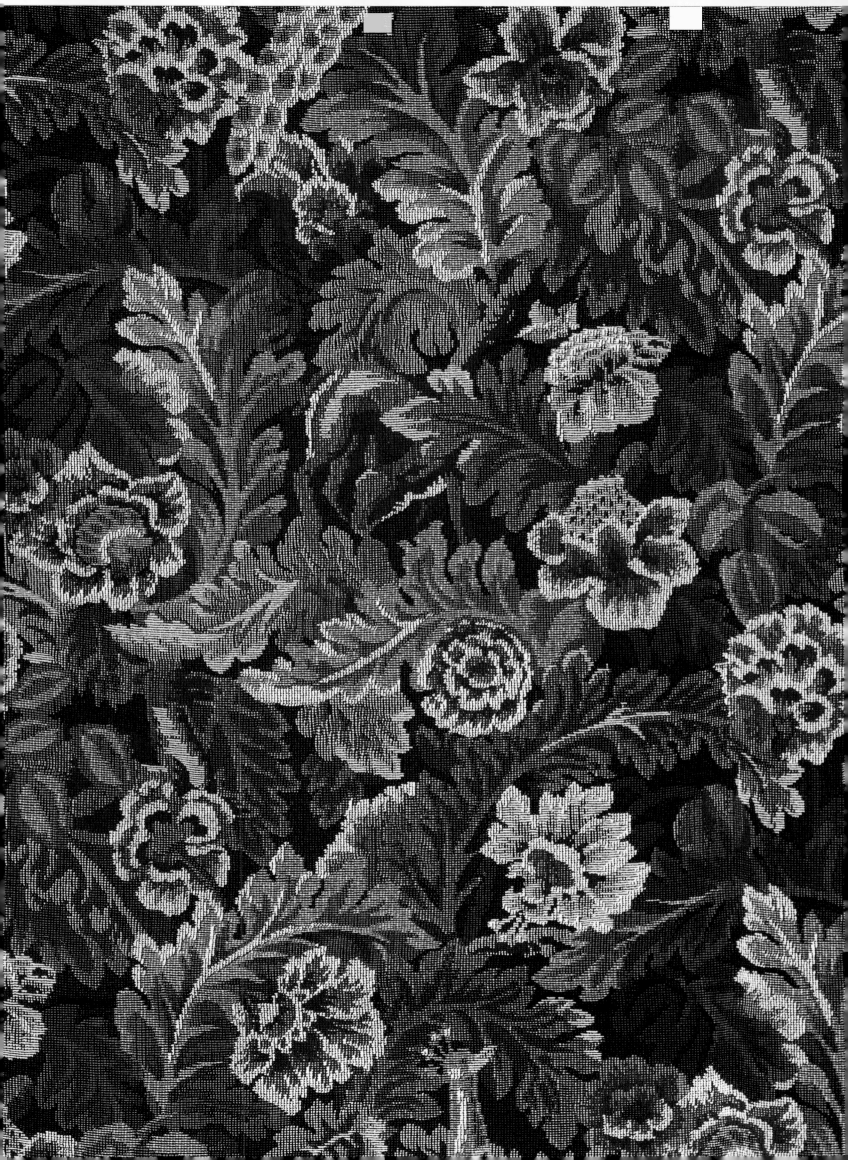

CHAPTER TWO

A
Reputation
For
Tradition

competent to work in any of the popular idioms of the day. These professionals were well trained, either in the studios of major architects or in the academies abroad. Schumacher's was quite familiar with the various architectural design trends of the day and readily assisted designers and their clients in finding the correct fabrics to complement their rooms.

For the millionaire client, the people who epitomized elegance and sophistication were the French. Thanks to the successful designs of Richard Morris Hunt commissioned by the Astors and the Vanderbilts during the Gilded Age, the classic Ecole des Beaux-Arts designs became firmly implanted as *the* style for the American decorating establishment. To this day, we associate French decor with refinement and good taste.

An Early Louis XV Design of Rare Beauty

The original brocade which inspired this exquisite fabric is now preserved in the Besselievre Collection.

An achievement in modern textile weaving, this brocade is characteristic of the beauty and rare quality which distinguish Schumacher fabrics. It is appropriately used for hangings and furniture coverings in interiors reflecting the atmosphere of the transition period between Louis XIV and Louis XV.

The artistic appreciation which characterizes the designing of Schumacher brocades and damasks and the skill with which they are woven

places them among the finest fabrics of all time. In addition to brocades and damasks the Schumacher collection includes tapestries, velvets and interesting linen prints.

Your own decorator or upholsterer will make arrangements for you to see the Schumacher fabrics including the brocade illustrated. He will also arrange the purchase for you.

F. Schumacher & Co., Importers, Manufacturers and Distributors to the trade only, of Decorative Drapery and Upholstery Fabrics, 60 West 40th Street, New York City. Offices in Boston, Chicago and Philadelphia.

F·SCHUMACHER & CO.

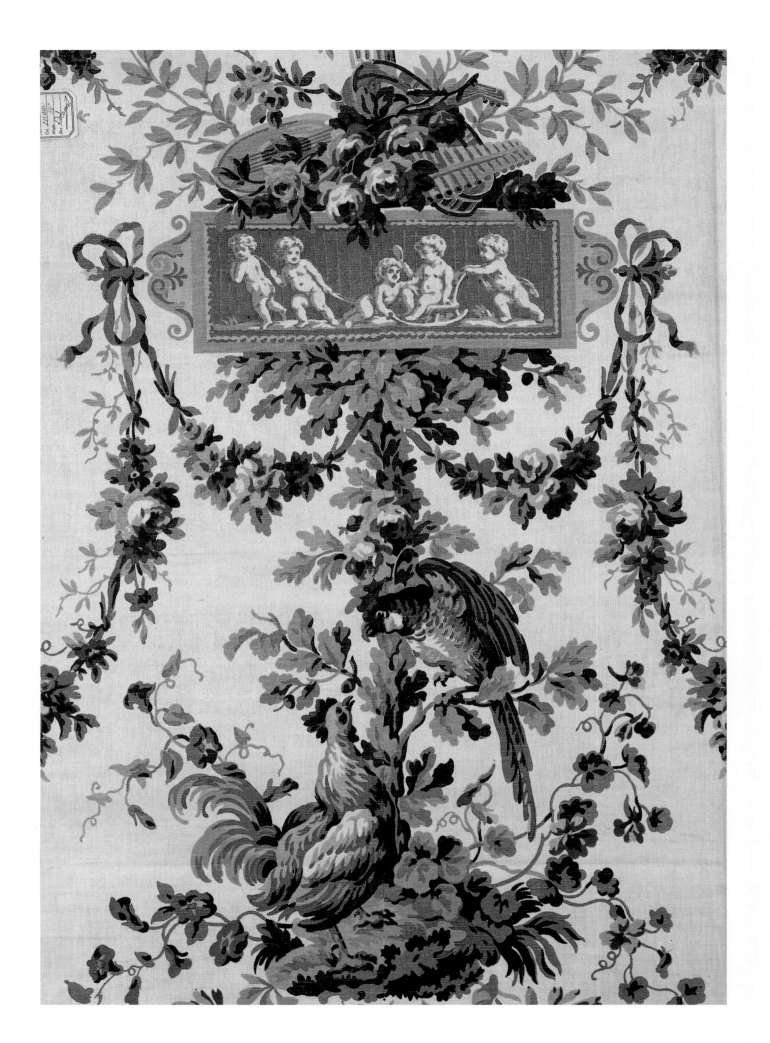

The richly appointed rooms decorated in the palatial French styles were not within the means of the middle class, and even millionaires found these rooms unlivable. Around 1920 a solution was found in a French rustic style known as Norman or Norman Provincial. Based on the simple decor associated with the farmhouses of rural Normandy, this newest architectural and decorative style became what we know today as Country French. Both city apartment and suburban home dwellers took to this new interpretation of French taste with relish.

For F. Schumacher & Co., the popularity of French furnishings ensured the firm's success. Both Frederic Schumacher and Pierre Pozier were proud of their French citizenship and the textile heritage they represented. Originally founded as importers of French textiles, Schumacher's primary purpose was to showcase these fabrics.

The various French styles Schumacher featured ranged from designs representative of François I of the mid-sixteenth century to those of Louis XIV, XV, and XVI of the eighteenth century, and finally to the creations identified with Napoleon I and III and Louis XVIII of the nineteenth century. Whether they were the opulent silk brocades so prized by the French court or the simple printed cottons and linens of the country French, these fabrics have remained popular at Schumacher for over a hundred years.

In the early decades after 1900, respected decorators known for their preference for French classicism—Ogden Codman, Edith Whar-

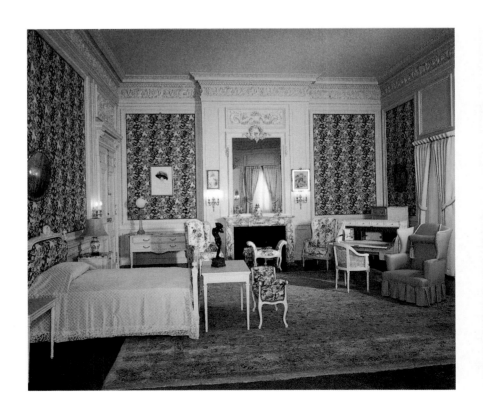

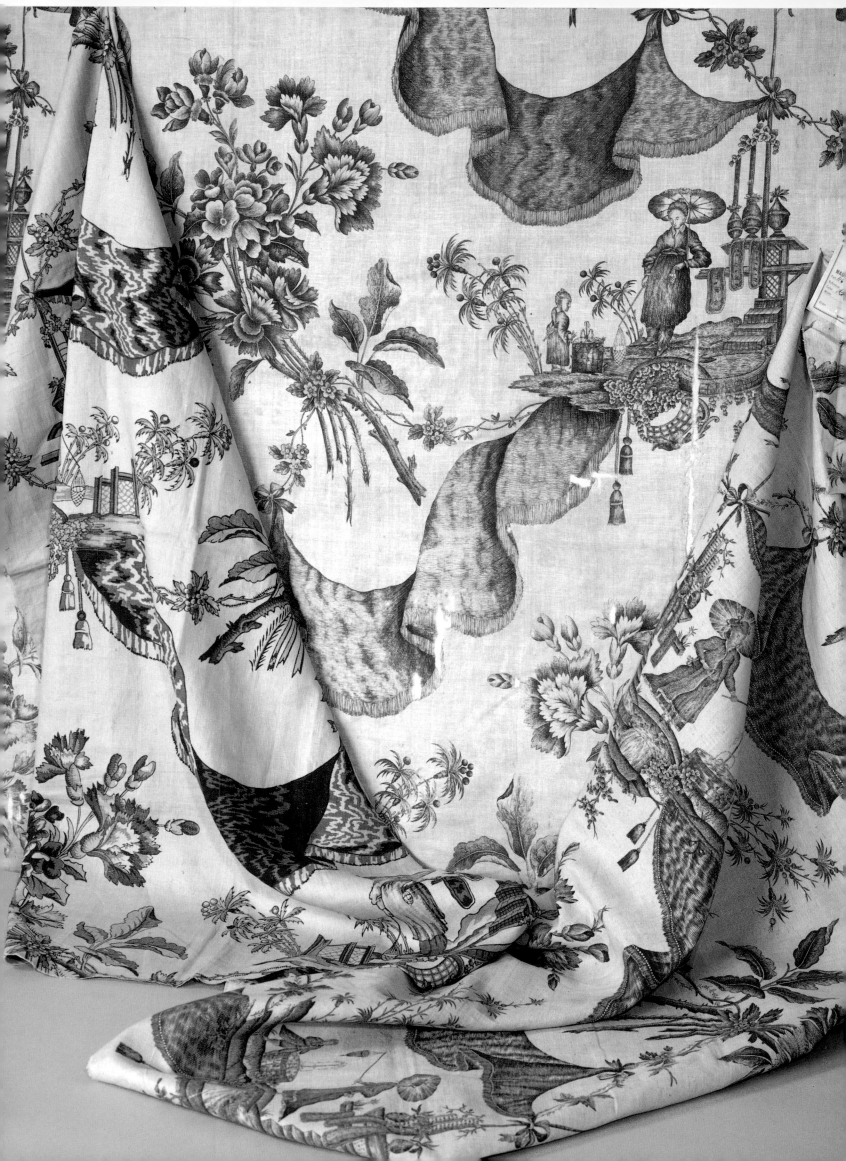

Plate 52

THE TOILE LA DRAPERIE, *LEFT,* WAS ORIGINALLY DESIGNED IN THE STYLE OF MADAME DE POMPADOUR, THE FAVORITE OF KING LOUIS XV. AS PATRONESS OF THE DECORATIVE ARTS, HER TASTE WAS MUCH ADMIRED AND COPIED. THIS CHARMING CHINOISERIE DESIGN OF BILLOWING DRAPERY, CHINESE FIGURES, AND BOUQUETS OF FLOWERS HAS BEEN IN DEMAND AT SCHUMACHER SINCE THE 1890S AND HAS BEEN REVIVED IN MANY VERSIONS. SHOWN HERE, AT CENTER, IS THE EIGHTEENTH-CENTURY DOCUMENT FLANKED BY TWO SCHUMACHER VARIATIONS. (ANTIQUE A.R. 39½″; OTHER A.R.'S RANGE FROM 34″ TO 40½″)

Plate 53

THIS SILK BROCADE, C. 1890, *RIGHT,* IS A REPRODUCTION OF AN EIGHTEENTH-CENTURY CHINOISERIE DESIGN BY PHILIPPE DE LASALLE. BRILLIANT COLORED SILK YARNS STAND OUT AGAINST A SATIN GROUND OF BLACK ON BLACK IN A MINUTE DIAPER PATTERN. THIS PARTICULAR CHINESE PHEASANT DESIGN, A FAVORITE AT SCHUMACHER, HAS APPEARED IN VARIOUS GUISES AS DAMASKS, BROCATELLES, AND PRINTED LINENS. (A.R. 60″)

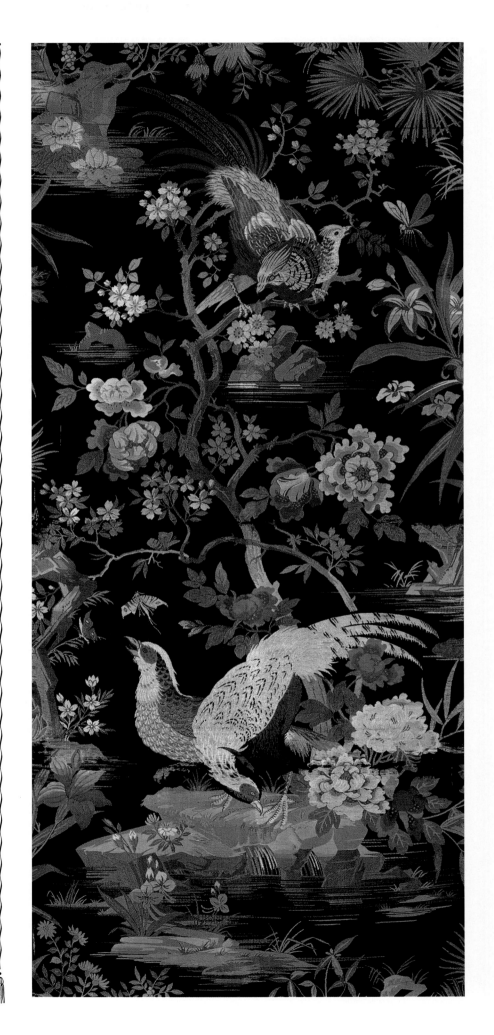

Plate 54

When it comes to richly col-
ored silk, this brocaded panel
of 1920 has few peers. The de-
sign and coloring are evocative
of the magnificent creations
associated with the mid-nine-
teenth-century Second Empire
style. An expensive fabric, this
panel sold for $55.00 in 1924.
(A.R. 57″)

and traditions. Except for the overwhelmingly popular fad for American Colonial Revival style, no styles have achieved more popularity than the English. Included in this category are period designs in Tudor/Jacobean, Georgian, Adamesque/Regency, and Victorian.

Although English fashions have influenced American architecture and decorative arts since the seventeenth century, it wasn't until after World War I that half-timbered English villages and houses began to appear in our suburbs—in many instances forming entire communities and developments. Schumacher has carried a selection of English textile designs in the line since the 1890s. Whether used in a mansion, a suburban house, or an apartment, English fabrics for every period interior could be found. Queen Anne crewel embroideries, Georgian brocades and damasks, Jacobean printed linens, Adamesque prints and damasks, Victorian floral, and sporting chintzes are just a few of the fabrics in this collection.

Springwood, the Roosevelts' English Georgian-style mansion in Hyde Park, New York, has long been decorated with Schumacher fabrics. This sprawling formal house, filled with heirlooms and souvenirs, was furnished with comfortable overstuffed furniture covered in traditional English prints that helped create a homey atmosphere. Floral prints, especially chintz, seemed to suit the Roosevelts' down-to-earth lifestyle.

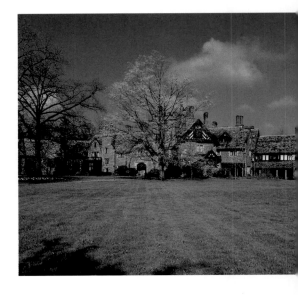

Plate 55

STAN HYWET HALL IS A TUDOR-STYLE MANSION IN AKRON, OHIO, DESIGNED BY CHARLES S. SCHNEIDER FOR FRANK A. SEIBERLING, A FOUNDER OF GOODYEAR RUBBER, IN 1912–15 (PHOTOGRAPH BY BARB SCHLUETER, 1988).

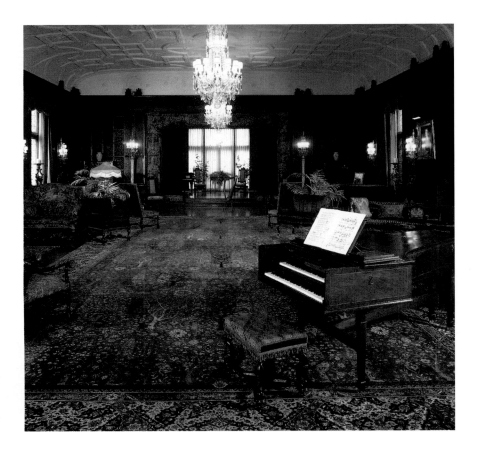

Plate 56

THE MUSIC ROOM AT STAN HYWET HALL, WHILE PREDOMINANTLY ENGLISH IN ITS ARCHITECTURAL TREATMENT, IS DECORATED WITH TEXTILES OF DIFFERENT EUROPEAN PERIODS AND STYLES. A SCHUMACHER VELOURS DE GENES STILL REMAINS ON TWO HIGH-BACK CHAIRS. THERE IS EVIDENCE THAT DAMASK PATTERN 253 WAS ONCE USED FOR SOME OF THE UPHOLSTERED FURNITURE (PHOTO BY GREG SOULO, 1988).

Plate 60

Sporting prints—usually scenes of the hunt, racing, and coaching—were popular in eighteenth-century England and France as toiles. In the nineteenth century, they took on new life in multicolored cottons and glazed chintzes. The prints have enjoyed an unflagging popularity for 150 years but are normally relegated to rooms used by the men of a household, such as dens, libraries, and game rooms. These Schumacher glazed cotton chintzes, *right,* View Halloo of 1929 and Tallyho of 1932, are good examples of this subject. (A.R.'s 24″ and 24½″)

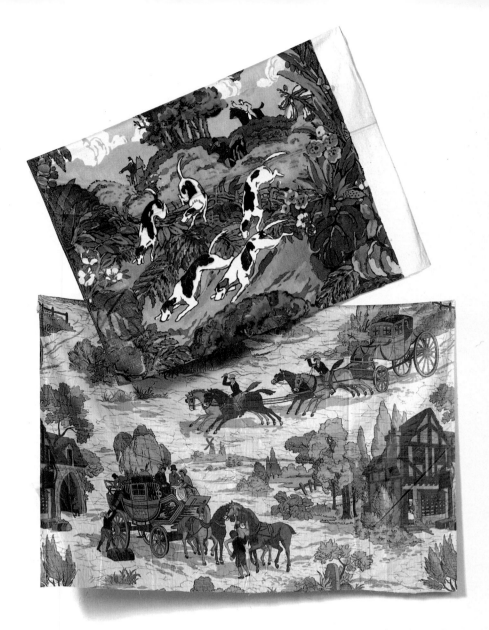

Plate 61

This gaily colored floral chintz of 1929, *right,* is a type that has been popular since about 1840. It is interesting to note that even though the French have made some of the world's most beautiful floral chintzes, in the United States we usually associate these designs with Victorian England. (A.R. 19¾″)

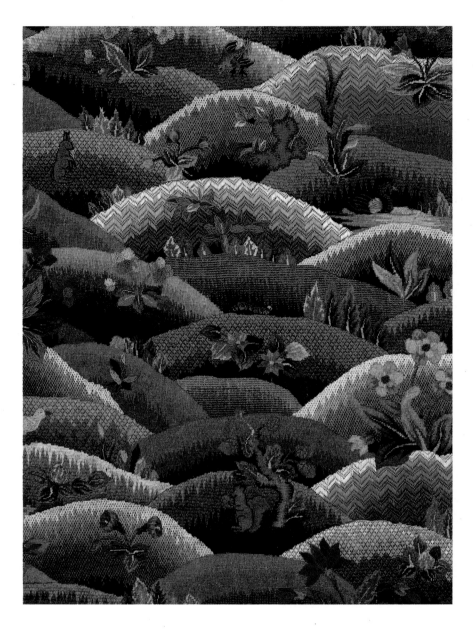

Plate 62

Until the advent of machine-made embroidery, crewelwork was available only by custom order, with a waiting period of as much as a year or more. This delightful embroidery of wool on burlap, c. 1950, is alive with cartoonlike fauna set amid rolling hills. Fabric of this type, having the density of tapestry, was favored for use as upholstery. This English fabric is a showroom sample available by custom order. (A.R. 28″)

Although American Colonial Revival architecture achieved a distinct and separate identity from the English, this was not the case in textiles. Fabrics for the American Colonial interior were the basic English damask, print, and needlework designs. During the first decades of this century, reproductions of authentic historic American textiles were limited to a small selection of commemorative toiles and prints.

Textiles that transcended almost all nationalistic and chronological divisions for room furnishing were those exotic creations inspired by Chinese and Indian sources. For ages, the fabrics of both the Near and Far East have influenced Western textiles and have been prized features of interior decoration. Americans have always been fascinated by the mysterious East, and Oriental-style fabrics have appeared in household inventories since the eighteenth century (Chinese silks and East Indian prints may have been used here even earlier).

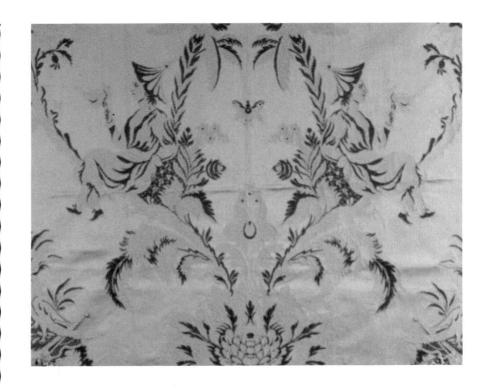

Plate 66

THIS CHINESE PATTERN TAKEN FROM AN EIGHTEENTH-CENTURY SOURCE HAS A LONG HISTORY AT SCHUMACHER—BEGINNING WITH ITS FIRST INCARNATION IN 1905, ANOTHER VARIATION IN 1915, A THIRD IN 1935, AND THIS PATTERN OF 1981. THIS LAMPAS IN COTTON WAS MADE TO REPRODUCE THE EARLIEST VERSION THAT HAD BEEN USED IN THE ELMS. (A.R. 39¾")

One of the most beautiful extant Gilded Age chinoiserie rooms done with Schumacher fabric is in the opulent Newport cottage The Elms, built for the coal czar Edward Julius Berwind. Known as the Chinese Breakfast Room, this exquisite Louis XV interior showcases Chinese lacquer panels inset in the stained and gilded boiserie. The draperies and table cover are of a Schumacher lampas featuring motifs of palm trees and coolies derived from an eighteenth-century source. Another Chinese-style lampas in a fantasy of flowers and playful Oriental people was commissioned from Schumacher by Horace Trumbauer, the same architect who designed The Elms, for the dining room of White Marsh Hall in Chestnut Hill, near Philadelphia. This mansion, alas not surviving today, was on a truly grand scale, as befitted Edward T. Stotesbury, the millionaire stockbroker who built it.

Textiles inspired by or made in India have always had as much appeal in this country as the Chinese designs. Indian designs have been well represented in the Schumacher line since the 1890s. These fabrics were mostly cotton prints, with a selection of crewel embroideries to add variety, and were much sought after by decorators. The print collection had the expected yard goods but also included panels that ranged in size from table scarves to large-scale palampores (bedspreads) and wall hangings.

Isabelle, an Indian crewelwork recently reintroduced to the line, is a design of exotic birds and flowers in a trailing vine pattern. It was used for draperies in eighteenth century-style public rooms in the Statler Hotel in Cleveland, Ohio, and the Lawrence Hotel in Erie,

Pennsylvania. Indian designs and motifs were used for velvets and damasks that decorated rooms of almost every style from Italian Renaissance to English Georgian, and even French Louis XVI, while American Colonial Revival rooms were often decorated with crewel embroideries and cotton prints.

At the opening of the San Diego Panama-Pacific Exposition of 1913, the American public crowded to a fair where they beheld buildings that both surprised and delighted them. Housing the exhibitions were structures designed by the architect Bertram Goodhue. He created a romantic new style of architecture using lavish ornament in what he called Spanish Churriguesque, which was eventually popularized as Spanish Colonial Revival. The fascination for America's Hispanic heritage grew, especially in California and Florida, and it wasn't long before houses in the Spanish Colonial style—distinguished by stucco walls, red tile roofs, beam ceilings, and tile floors—made their appearance all across this country.

Since the 1880s, Italian/Mediterranean architecture in the United

Plate 67

THE MAGNIFICENTLY PANELED CHINESE BREAKFAST ROOM AT THE ELMS GETS ITS NAME FROM THE CHINESE BLACK-LACQUERED PANELS THAT HAVE BEEN INCORPORATED IN THE WOODWORK. THE CHINOISERIE LAMPAS HAS BEEN USED FOR THE WINDOW TREATMENTS AND FOR THE TABLECLOTH (PHOTOGRAPH 1988).

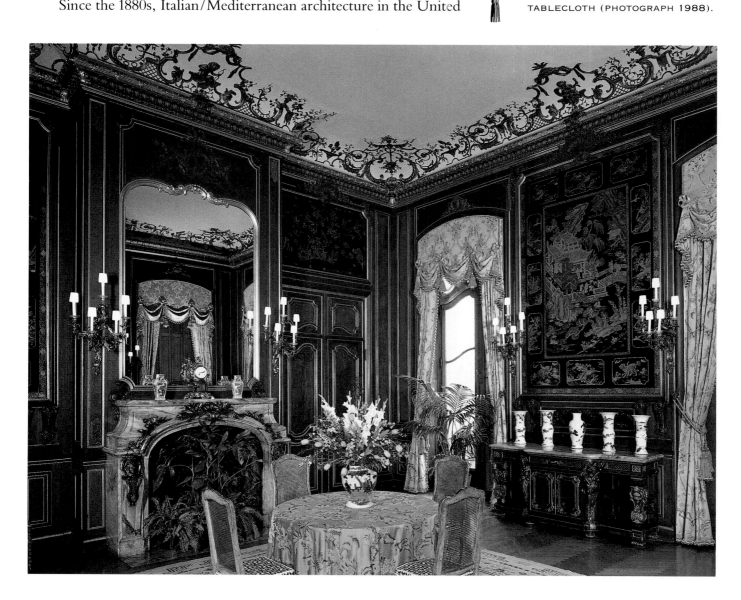

Plate 76

It is not unusual for a pattern to be made in a number of mediums. This silk Velours de Genes (velvet) and silk lampas, 1915, of the same design were inspired by a sixteenth-century velvet from the silk mills of Genoa and Venice. Schumacher has recently reproduced this design in a damask weave. (Velvet, A.R. 29½"; lampas, A.R. 31")

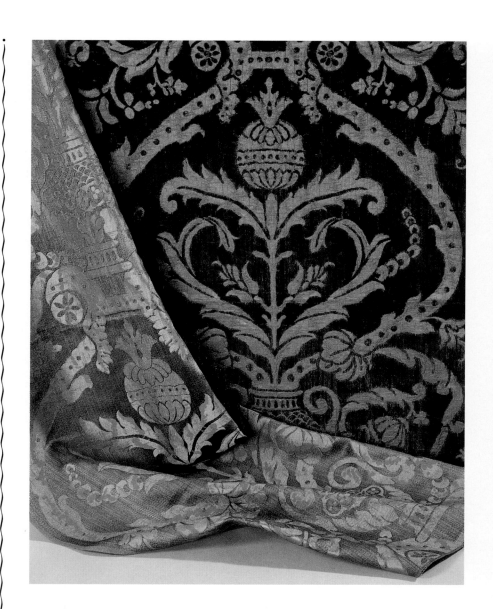

Plate 77

This 1923 photo of furniture in the Music Room of Stan Hywet Hall shows the Schumacher Velours de Genes still in use on the high-back chairs.

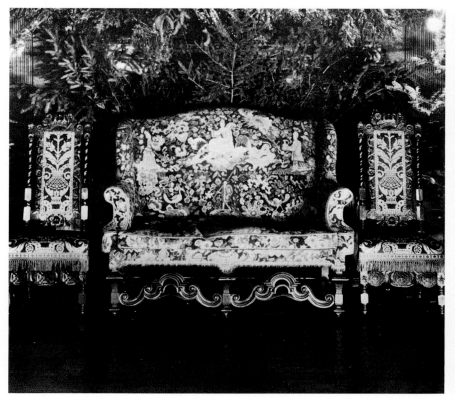

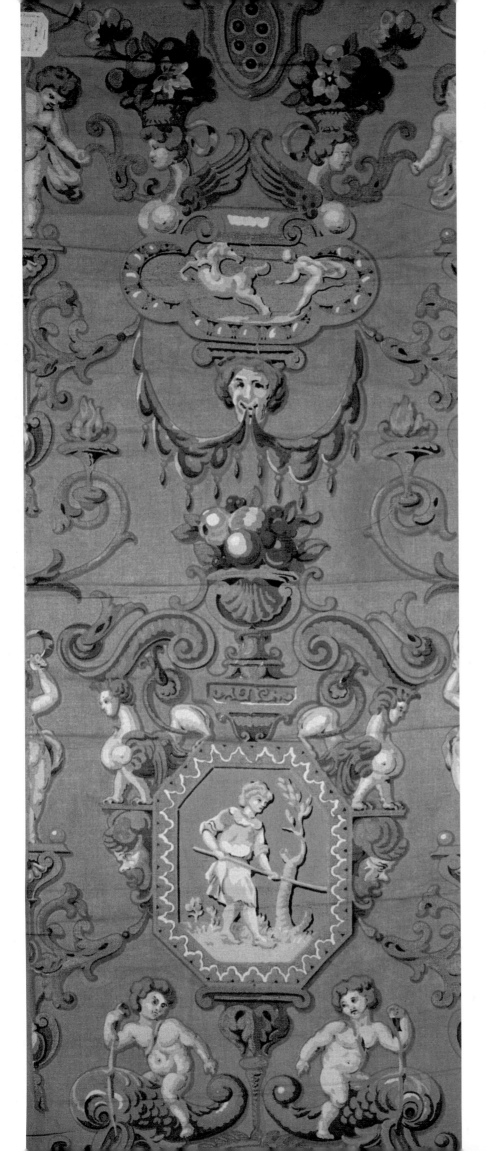

Made in a variety of styles, printed linens were extremely popular for decorating during the early decades of this century. This 1927 linen printed in Pompeian motifs, *LEFT,* was created for use with Italianate-Mediterranean decors. Sources for these designs came from the archaeological discoveries of excavations, such as those found on wall paintings, mosaics, and pottery. (A.R. 67½")

Plate 79

It is customary for the firm's designers to travel abroad seeking new products and sources for designs. While in Europe at the turn of the century, Pierre Pozier did this tracing and gouache on tissue, *ABOVE,* of a small stylized flower pattern; he identified it as "XVI Century Spanish." It was reproduced at Schumacher's mill as a silk damask in 1905. (A.R. 4¾")

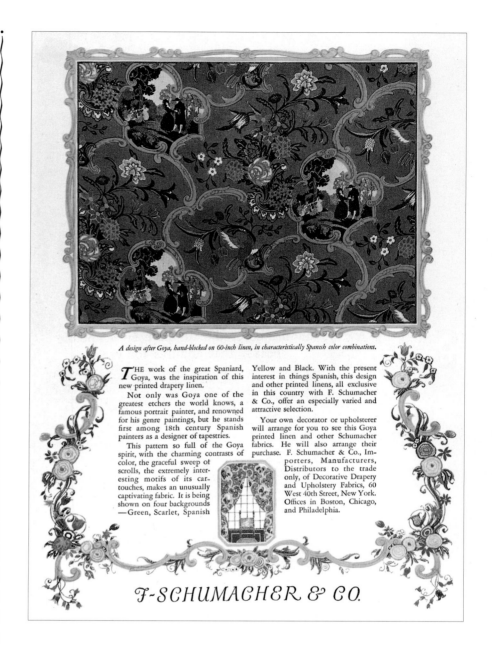

A design after Goya, hand-blocked on 60-inch linen, in characteristically Spanish color combinations.

THE work of the great Spaniard, Goya, was the inspiration of this new printed drapery linen.

Not only was Goya one of the greatest etchers the world knows, a famous portrait painter, and renowned for his genre paintings, but he stands first among 18th century Spanish painters as a designer of tapestries.

This pattern so full of the Goya spirit, with the charming contrasts of color, the graceful sweep of scrolls, the extremely interesting motifs of its cartouches, makes an unusually captivating fabric. It is being shown on four backgrounds —Green, Scarlet, Spanish Yellow and Black. With the present interest in things Spanish, this design and other printed linens, all exclusive in this country with F. Schumacher & Co., offer an especially varied and attractive selection.

Your own decorator or upholsterer will arrange for you to see this Goya printed linen and other Schumacher fabrics. He will also arrange their purchase. F. Schumacher & Co., Importers, Manufacturers, Distributors to the trade only, of Decorative Drapery and Upholstery Fabrics, 60 West 40th Street, New York. Offices in Boston, Chicago, and Philadelphia.

F·SCHUMACHER & CO.

Edgewater Tapestries. Although most of Edgewater's tapestries were based on traditional European designs, the Schumacher stock scrapbook of their collection also includes panels that were purely American in subject matter.

Unfortunately, because tapestry panels have not been popular for use in interior decoration in the United States during the last fifty years, Schumacher does not include any in the current collection. However, the firm does maintain a small selection of tapestries used as yard goods. Of special note is the design La Biche, which is a reproduction of a 1920s pattern that once coordinated with a panel. With the current revival of interest in the opulent textiles of the past, perhaps large, richly colored scenic tapestry panels will reenter the inventory in the not-too-distant future.

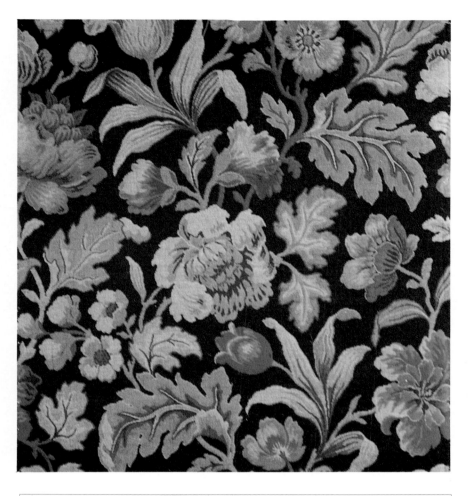

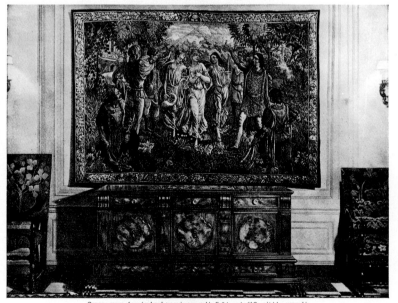
Plate 81

DESIGNED AS CONTINUOUS YARD GOODS, THIS WOOL TAPESTRY MATERIAL, *LEFT,* IS FOR USE AS UPHOLSTERY. ALTHOUGH IT DATES FROM 1915, THE MILLEFLEUR FLORAL DESIGN IS AGELESS. (A.R. 29+")

Plate 82

FROM THE MAGAZINE *GARDEN AND HOME BUILDER,* 1927, THIS IS AN ADVERTISEMENT FOR SCHUMACHER'S TAPESTRY PANEL THE SWORD DANCE, *BELOW LEFT.* ALTHOUGH NO LARGE PANELS SURVIVE IN THE ARCHIVES COLLECTION, THE AD ILLUSTRATES THE GRANDEUR OF THESE TAPESTRIES. TWO SCRAPBOOKS OF TAPESTRY PHOTOGRAPHS AND THREE CATALOGUES RECORD MOST OF THE MISSING COLLECTION.

Plate 83

OVERLEAF: LISTED AS A VERDURE PANEL, THIS TIGHTLY WOVEN AND RICHLY COLORED WOOL AND LINEN TAPESTRY IS OF A DESIGN USUALLY IDENTIFIED WITH THE LOOMS OF SAVONNERIE. ONLY 24½ INCHES WIDE, THIS 1910 TAPESTRY WAS INTENDED FOR USE AS A BORDER OR AS A CENTER PANEL FRAMED BY VELVET OR DAMASK ON SEATING FURNITURE. (A.R. 27")

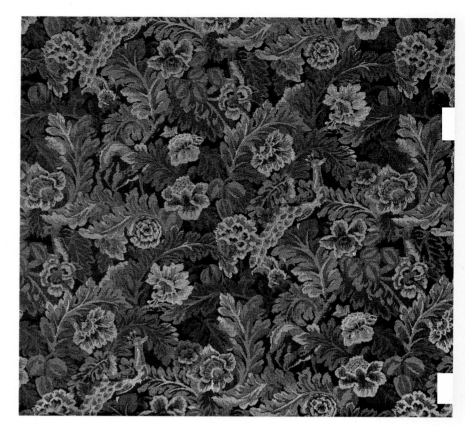

Plate 84

Tᴴɪꜱ ʜᴀɴᴅ-ʟᴏᴏᴍᴇᴅ ᴡᴏᴏʟ ᴠᴇʀᴅᴜʀᴇ ᴛᴀᴘᴇꜱᴛʀʏ ᴡᴀꜱ ᴏʀɪɢɪɴᴀʟʟʏ ᴅᴇ-ꜱɪɢɴᴇᴅ ᴛᴏ ᴄᴏᴏʀᴅɪɴᴀᴛᴇ ᴡɪᴛʜ Lᴀ Bɪᴄʜᴇ, ᴀ ʟᴀʀɢᴇ ꜱᴄᴇɴɪᴄ ᴛᴀᴘᴇꜱᴛʀʏ ᴘᴀɴᴇʟ. Tʜᴇ 1924 Sᴄʜᴜᴍᴀᴄʜᴇʀ ᴛᴀᴘᴇꜱᴛʀʏ ᴄᴀᴛᴀʟᴏɢᴜᴇ ɪʟʟᴜꜱᴛʀᴀᴛᴇꜱ ᴛʜɪꜱ ᴠᴇʀᴅᴜʀᴇ ꜰᴏʀ ᴏᴄᴄᴀꜱɪᴏɴᴀʟ ᴄʜᴀɪʀ ᴄᴏᴠᴇʀɪɴɢꜱ. (A.R. 28¾")

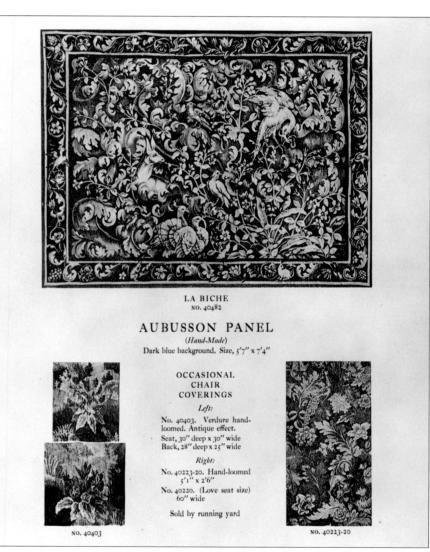

LA BICHE
NO. 40482

AUBUSSON PANEL
(Hand-Made)
Dark blue background. Size, 5'7" x 7'4"

OCCASIONAL
CHAIR
COVERINGS

Left:
No. 40403. Verdure hand-loomed. Antique effect.
Seat, 30" deep x 30" wide
Back, 28" deep x 25" wide

Right:
No. 40223-20. Hand-loomed
5'1" x 2'6"
No. 40220. (Love seat size)
60" wide

Sold by running yard

NO. 40403

NO. 40223-20

Plate 85

Tᴴɪꜱ ᴘᴀɢᴇ ɪɴ ᴛʜᴇ 1924 ᴄᴀᴛᴀʟᴏɢᴜᴇ *Tᴀᴘᴇꜱᴛʀɪᴇꜱ ꜰᴏʀ Wᴀʟʟ Dᴇᴄᴏʀᴀᴛɪᴏɴ ᴀɴᴅ Fᴜʀɴɪᴛᴜʀᴇ Cᴏᴠᴇʀɪɴɢ* ꜰᴇᴀ-ᴛᴜʀᴇꜱ ʙᴏᴛʜ ᴛʜᴇ ᴘᴀɴᴇʟ ᴀɴᴅ ᴛʜᴇ ᴠᴇʀᴅᴜʀᴇ ᴛᴀᴘᴇꜱᴛʀʏ Lᴀ Bɪᴄʜᴇ.

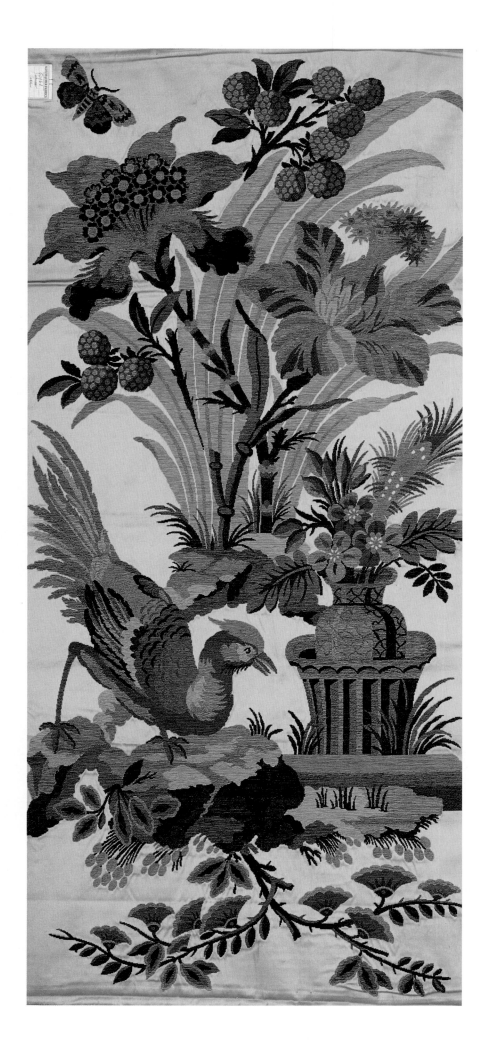

Plate 86

THIS CHENILLE AND SILK BROCADE
PANEL, C. 1920, IS AFTER AN EARLY
LASALLE DESIGN IN THE ROCOCO
CHINOISERIE STYLE OF LOUIS XV.
THE USE OF THE DULL-COLORED
CHENILLE IN HIGH RELIEF AGAINST
THE SHIMMERING SATIN GROUND
CREATES A NOVEL EFFECT. (A.R. 53″)

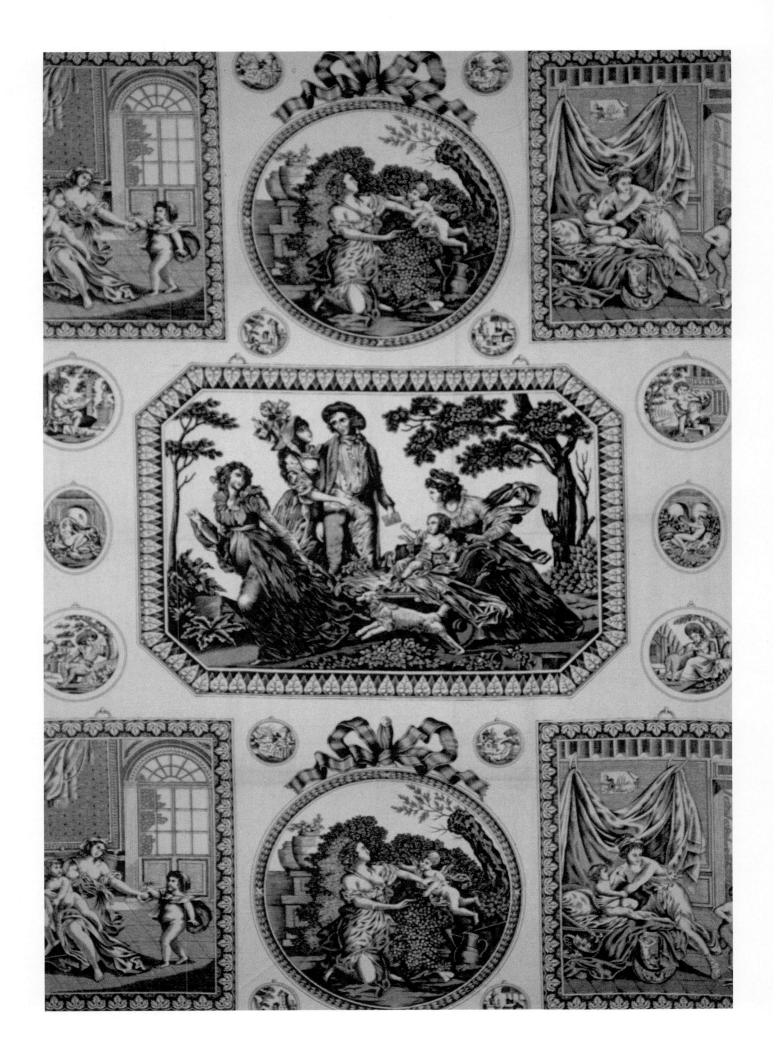

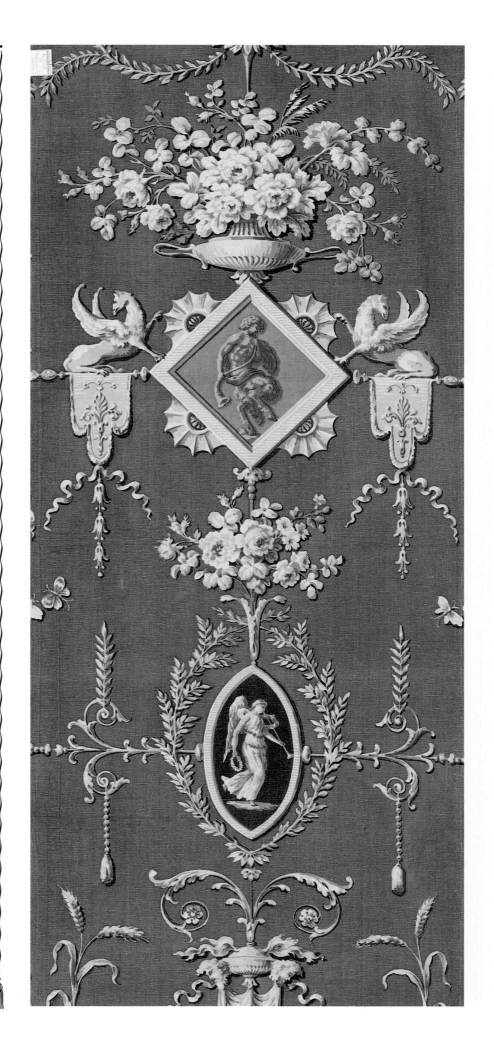

Plate 87

LES TABLEAUX, *LEFT,* A LINEN TOILE OF 1924, IS A REPRODUCTION OF A 1795 PRINT BY PETITPIERRE ET CIE, AND RECALLS THE DESIGNS FOR WHICH THE FRENCH ARTIST JEAN-BAPTISTE HUET WAS SO FAMOUS. SCHUMACHER ILLUSTRATED THIS TOILE IN COLOR IN ITS 1924 CATALOGUE. (A.R. 31½")

Plate 88

ACCORDING TO SCHUMACHER LEAFLET 22, THE WALL PAINTINGS OF POMPEII WERE THE INSPIRATION FOR THIS ELEGANT 1922 PRINTED LINEN PANEL, *RIGHT.* OTHER DESIGNS IN THIS STYLE WERE ALSO AVAILABLE. LARGE-SCALE PANELS OF THIS TYPE WERE USED FOR WALLS, FOLDING SCREENS, AND DRAPERIES IN THE HANDSOME NEOCLASSICAL ROOMS THAT WERE PREVALENT DURING THE EARLY DECADES OF THIS CENTURY. (A.R. 79")

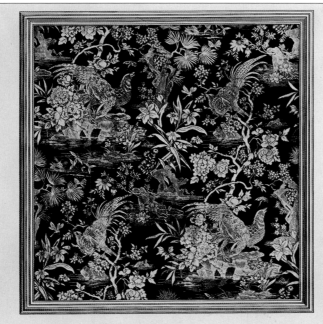

Silk Damask after Philippe de Lasalle

The pattern of this damask originated in a broché silk designed in the 18th Century by Philippe de Lasalle of Lyons.

The golden pheasant motif is characteristic of Lasalle's art. Birds, flowers, foliage and symbolic ornaments were almost ever-present in his works and no one could compose them more beautifully.

This particular design, as worked out in damask, is quite remarkable in that the pattern does not repeat itself across the entire width of 50 inches—a technical achievement possible on few looms in existence. In adapting the design to this width, the perfect balance and harmony of line of the original have been successfully preserved.

In determining patterns for damasks and brocades, Schumacher designers go to the master weavers of past centuries for their inspiration. In addition they create exclusive designs and weaves reflecting the tendencies of the decorative arts today. Many of these designs are woven on Schumacher's own looms by the most skilled weavers procurable. Schumacher's fabrics may be seen and purchased through your own decorator or upholsterer.

F. Schumacher & Co., Importers, Manufacturers, Distributors to the trade only of Decorative Drapery and Upholstery Fabrics. 60 West 40th Street, New York. Offices in Boston, Chicago, and Philadelphia.

F. SCHUMACHER & CO.

Plate 89

SILK IMBERLINE DAMASKS SUCH AS THIS SCHUMACHER REPRODUCTION OF 1924, *LEFT*, WERE ORIGINALLY POPULAR IN THE LATE SEVENTEENTH CENTURY DURING THE REIGN OF LOUIS XIV. AN IMBERLINE COMBINES THE SPECIAL EFFECT OF A TRADITIONAL DAMASK DESIGN ACROSS MULTICOLORED STRIPES. IMBERLINE DAMASKS CONTINUE TO BE ESSENTIAL DESIGNS IN THE FIRM'S TRADITIONAL COLLECTION. (A.R. 26")

Plate 90

THE FIRM'S WEAVING MILL CREATED THIS PATTERN IN 1915, *RIGHT*, FROM THE CHINESE PHEASANT DESIGN OF PHILIPPE DE LASALLE. THIS ROYAL BLUE AND GOLD COLORWAY WAS KNOWN TO HAVE BEEN ON CUSHIONS FOR THE BLACK-LACQUERED REGENCY-STYLE FURNITURE IN THE SOLARIUM OF STAN HYWET HALL, AKRON, OHIO. (A.R. 53")

Plate 91

SCHUMACHER USED THIS 1923 ADVERTISEMENT, *LEFT*, TO PROMOTE ITS LASALLE CHINESE PHEASANT DAMASK FROM THE MILL COLLECTION.

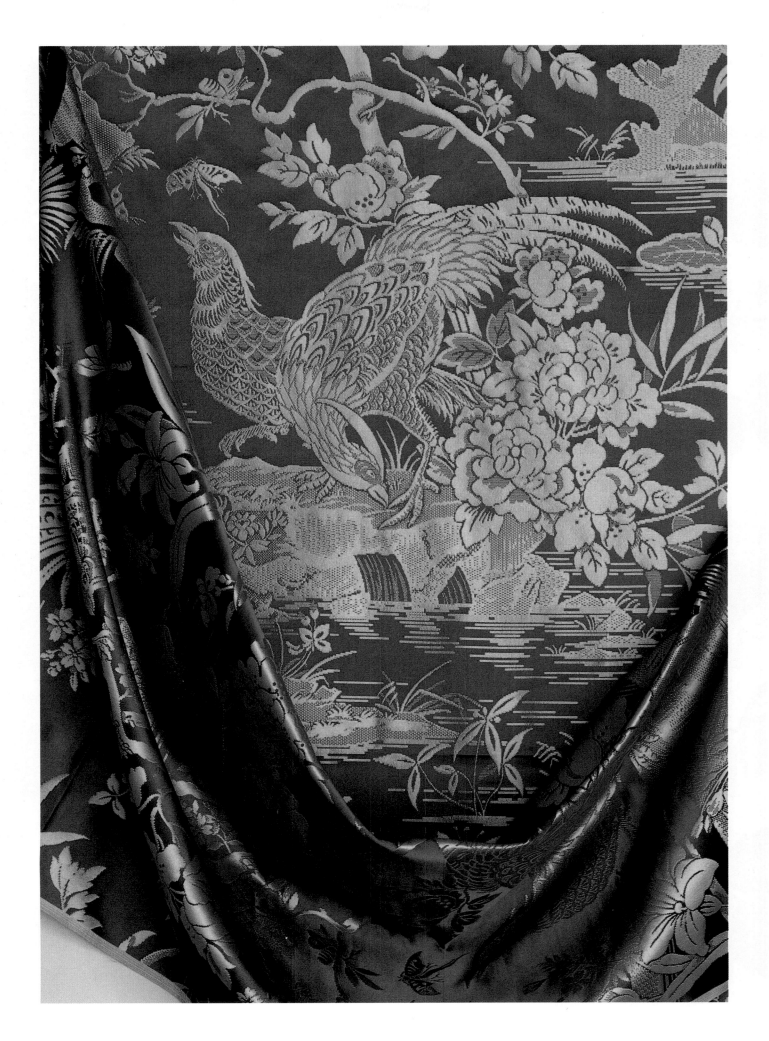

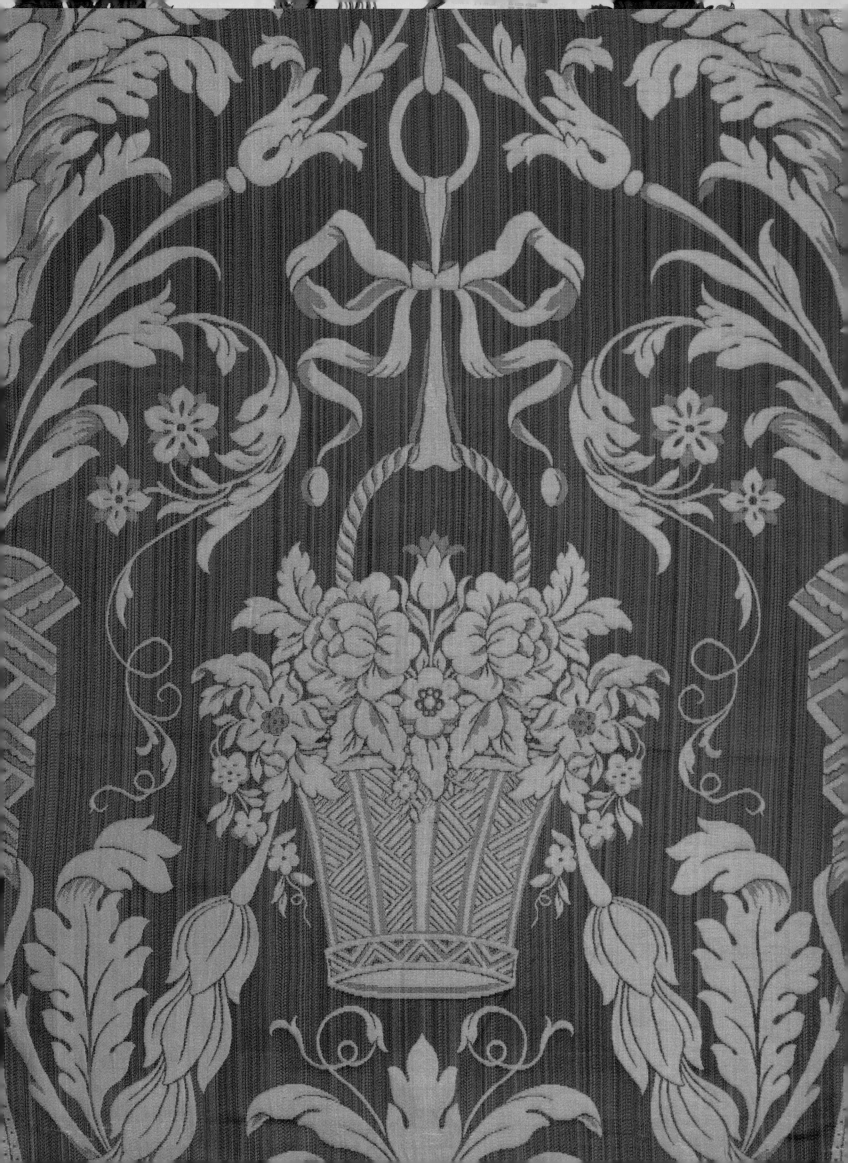

CHAPTER THREE

The
Prestige
Clientele

Plate 94
ARCHITECT STANFORD WHITE DE-
SIGNED THIS FABRIC, *LEFT*—THE
BLUE ROOM LAMPAS OF 1902—
CHOOSING THE LATE-EIGHTEENTH-
CENTURY DIRECTOIRE STYLE AS
SUITABLE FOR THE WHITE HOUSE.
THIS CUSTOM-MADE AMERICAN-
MANUFACTURED LAMPAS WAS FIRST
USED IN WHITE'S REDECORATION OF
THE WHITE HOUSE FOR PRESIDENT
AND MRS. THEODORE ROOSEVELT.
SUBSEQUENTLY REPRODUCED IN A
NUMBER OF SUCCEEDING ADMINIS-
TRATIONS, IT WAS STILL VERY MUCH
IN EVIDENCE DURING FIRST LADY
JACQUELINE KENNEDY'S FAMOUS TV
TOUR IN 1962. (A.R. 34¼")

Plate 95
THIS PORTRAIT OF EDITH KERMIT
CAROW ROOSEVELT, FIRST LADY
FROM 1901 TO 1909, WAS PAINTED
BY THEOBALD CHARTRAN, WITH THE
SOUTH PORTICO OF THE WHITE
HOUSE USED AS A BACKDROP.

PRECEDING SPREAD:
SEE Plate 117.

In the history of F. Schumacher & Co., no customer has been more consistently courted than the prestige clients, who were primarily architects and decorators. Beginning with Frederic Schumacher, the company has made a point of providing good service as well as value to customers desiring quality textiles—which in many instances are in custom colors or even custom designs. And with the opening of the firm's American mill in 1895, special orders became a part of the regular service available to any customer. It is the prestige clients who have selected or commissioned Schumacher creations to adorn mansions and public buildings, from the White House and U.S. Capitol to innumerable hotels and theaters all across the United States and abroad.

The Schumacher look, predicated on traditional European textiles, appealed to the company's early clientele of architects and decorators, who in large part helped the firm establish its reputation. These customers used Schumacher silk brocades and damasks in buildings from New York to San Francisco.

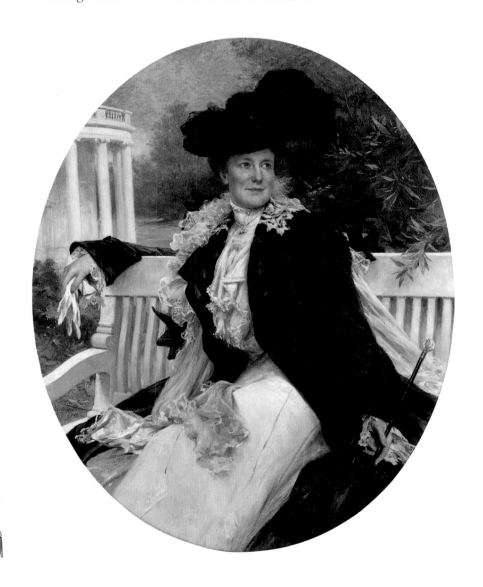

of elegance.

nedy era. This simple yet elegant design confirmed Schumacher Pres-
~~ident Piero Brigg's statement, "There is something noble in a fine~~

Not to be overlooked in the prestige category are the fabrics created for the transportation market. Schumacher became involved in this business during the early 1920s when it began to manufacture textiles in collaboration with Du Pont and some of the foremost industrial designers of the day. Designers such as Adolph Griven, Donald Deskey, and Ruth Reeves created fabric designs in rayon, in addition to more traditional fibers, for use in automobiles, airplanes, yachts, and even ships. Schumacher provided designer fabrics by Paul Rodier and Adolph Griven for the interiors of the German-manufactured Fokker planes in the Pan Am fleet, and special rayon moirés for the American-made Sikorsky planes. Enough business was generated for the firm to establish a division in 1929 to provide textiles for airplane interiors, headed by World War I flying ace Pierre Freyss. In later decades, they manufactured fabrics for military planes in World War II and for numerous commercial airlines after the war.

The Vanderbilt yacht *Vagabondia* was outfitted in Schumacher fabrics, as was America's first great luxury liner, the S.S. *Leviathan*, which the United States confiscated from Germany during World War I and refitted for passenger service in the early 1920s. During the 1950s, Raymond Loewy designed a collection of Schumacher fabrics that were featured in the refitted S.S. *Atlantic*. In this same decade, the company advertised that their "flame-proof fabrics were on board the S.S. *United States*."

It is interesting to note that in the decades since 1898, it has been possible to enjoy Schumacher fabrics in the hallowed halls of government, while stopping in a hotel, enjoying a performance at a theater, attending a religious service, or even when traveling by land, sea, or air.

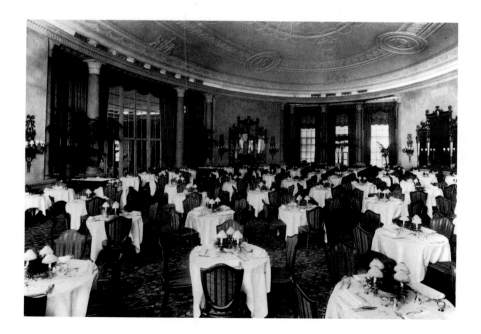

Plate 115

AMONG THE EARLY SCHUMACHER PATTERNS, THIS SILK DAMASK, *RIGHT*, FIRST PRODUCED IN 1903, IS PROBABLY THE BEST EXAMPLE OF AN ADAMESQUE DESIGN. THE OVAL SUNBURSTS, CLASSICAL URNS, AND WINGED GRIFFONS ARE TYPICAL OF THE NEOCLASSICAL MOTIFS IDENTIFIED WITH THIS STYLE. THIS CURRENT REPRODUCTION EDWARDIAN DAMASK WAS FORMERLY KNOWN AS PATTERN 400. (A.R. 34½")

Plate 116

EDWARDIAN DAMASK WAS CHOSEN FOR THE 1912 DECORATION OF THE DINING ROOM OF THE RITZ-CARLTON HOTEL IN NEW YORK CITY, *LEFT*. THE DECORATIVE MOTIFS IN THE SILK FABRIC ECHO THE STUCCO DESIGNS ON THE ROOM'S PLASTER CEILING (PHOTOGRAPH BY BYRON).

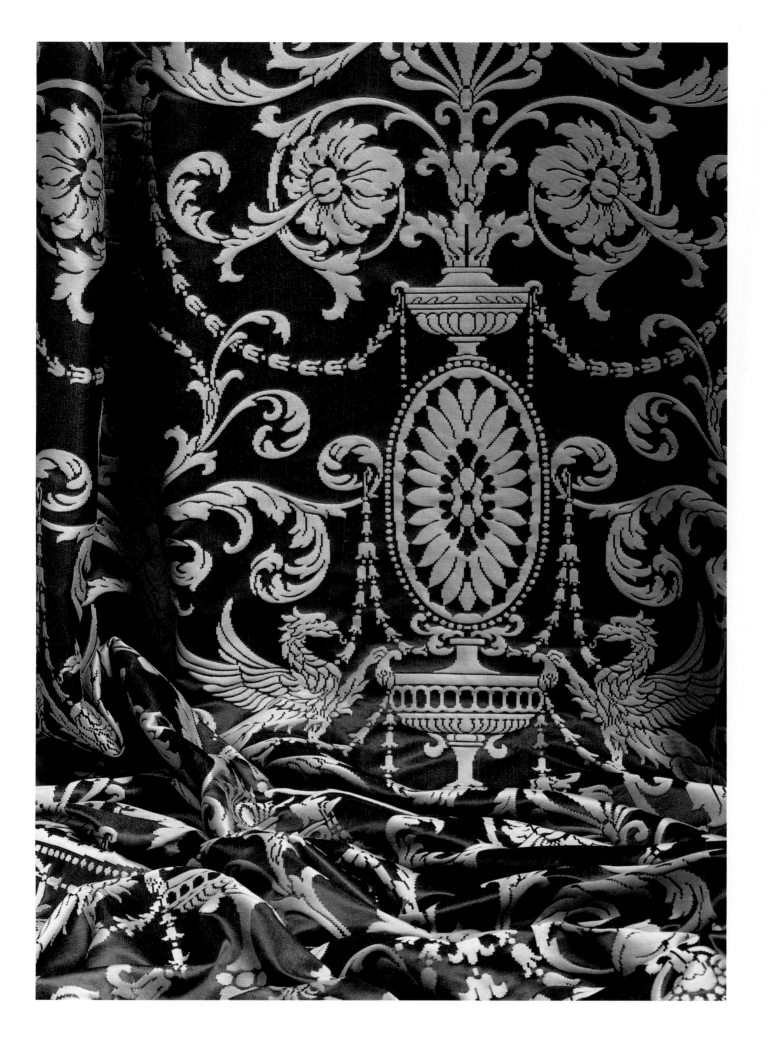

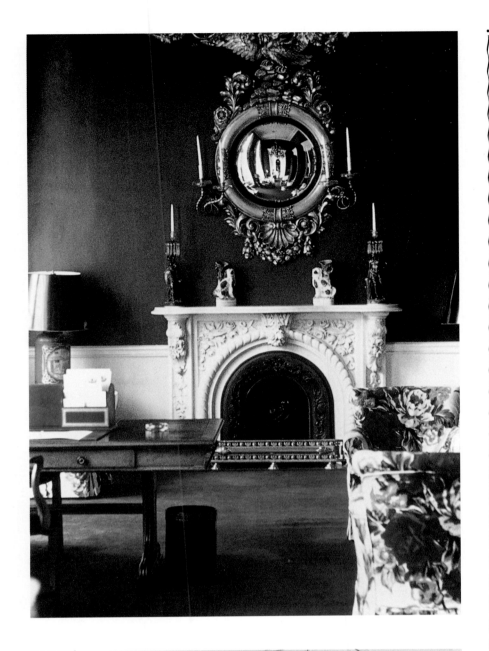

Plate 119

Right: This was one of several brightly colored prints that Schumacher produced from designs by decorator Dorothy Draper for her redecoration of the Greenbrier Hotel in White Sulphur Springs, West Virginia, after World War II. Miss Draper's palette for this project was dominated by rich green and "hunting red" as illustrated in this bold linen floral print that dates from 1946. (A.R. 39")

Plate 120

The floral print on the furniture in the Writing Room of the Greenbrier Hotel, *left,* is from the collection designed by Dorothy Draper (photograph 1959).

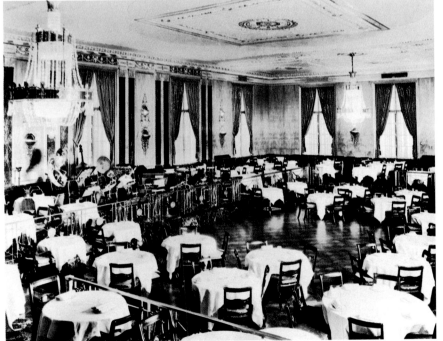

Plate 121

The windows of the Empire Room of the Waldorf-Astoria Hotel, 1935, *left,* were adorned with draperies made with the Empire Wreath damask (photograph by R. A. Smith).

Plate 122

Designs for these companion textiles, Obi and Obi Damask, *left*, were inspired by the sashes so much admired in traditional Japanese costumes. Recently introduced in 1989, these cotton damasks are meant for use with contemporary decor. (A.R.'s 13½″ and 14″)

Plate 123

The Sky Room in the La Valencia Hotel, La Jolla, California, *right*, is a modern restaurant that uses the Obi and Obi Damask for the walls and window treatments, 1990.

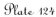

Plate 124

In 1982, a Schumacher cotton damask in a traditional eighteenth-century style, *right*, was chosen to replace the first house curtain in the New York State Theater at Lincoln Center. This pattern has been available at Schumacher since 1925 and is shown here with fringe as installed. (A.R. 26″)

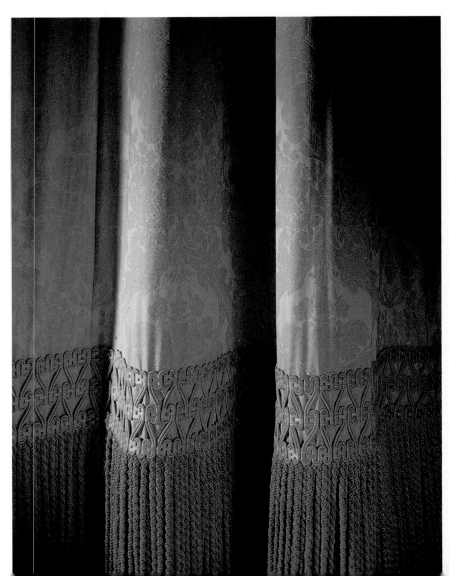

Plate 125

DURING WORLD WAR I, SCHU-
MACHER WAS FIRST COMMISSIONED
TO PROVIDE FABRICS FOR A THEATER.
E. F. ALBEE, WHO OWNED A CHAIN
OF THEATERS, BECAME INTERESTED
IN THE FIRM'S NEWLY DEVELOPED
"ALL-SILK ORGANZINE" DAMASK.
THE FABRIC, IF ORDERED IN QUAN-
TITY, WAS AVAILABLE AT A REASON-
ABLE PRICE, WHICH GREATLY SATIS-
FIED MR. ALBEE, WHO WENT ON TO
USE SCHUMACHER SILKS FOR ALL
HIS THEATERS. IN THIS VIEW, C.
1920, OF THE E. F. ALBEE THEATER
IN BROOKLYN, NEW YORK, THE OR-
GANZINE DAMASK IS SEEN ON THE
WALLS AND IN THE DRAPERIES.

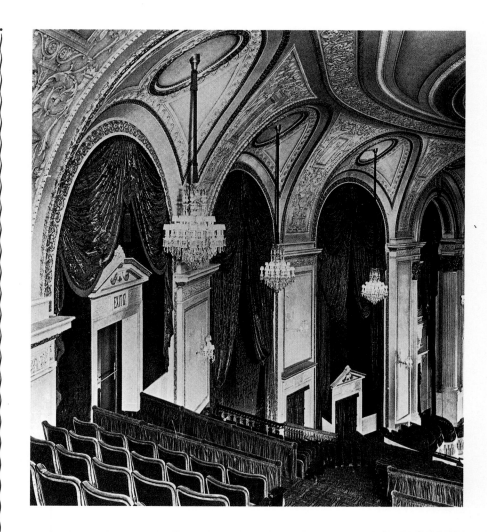

Plate 126

THIS 1930 PHOTOGRAPH OF THE
WORLD-FAMOUS METROPOLITAN
OPERA HOUSE IN NEW YORK CITY
SHOWS THE SCHUMACHER-MADE
HOUSE CURTAIN.

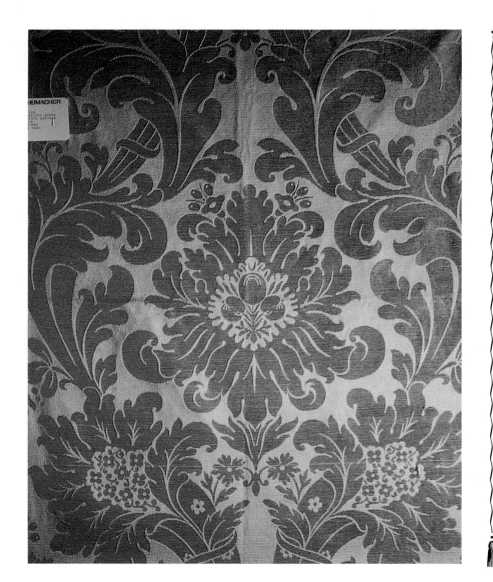

Plate 127

The majority of patterns used by theaters for house curtains are in traditional designs inspired by European seventeenth- and eighteenth-century silk designs. This silk brocatelle, *left*, created in 1967 for the San Francisco Opera House, is taken from a sample of an earlier curtain used by this same opera house. (A.R. 33″)

Plate 128

This recent view of the stage and orchestra of the San Francisco Opera House, *below*, shows the Schumacher house curtain.

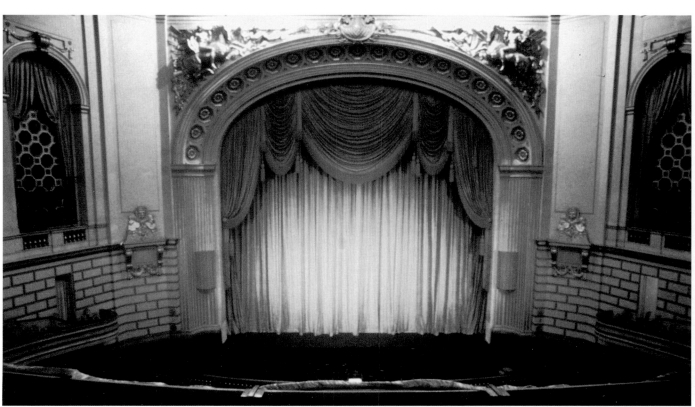

Massachusetts. (A.R. 19″)

Plate 129

A

Plate 133

Iɴ 1985, ᴀ ʜᴏᴜѕᴇ ᴄᴜʀᴛᴀɪɴ ᴍᴀᴅᴇ
ɪɴ ᴛʜᴇ Bʀᴇᴀᴋᴇʀѕ Dᴀᴍᴀѕᴋ ᴅᴇѕɪɢɴ
(ꜰʀᴏᴍ ᴛʜᴇ Hɪѕᴛᴏʀɪᴄ Nᴇᴡᴘᴏʀᴛ Cᴏʟ-
ʟᴇᴄᴛɪᴏɴ) ᴡᴀѕ ᴡᴏᴠᴇɴ ɪɴ ᴛʜɪѕ ᴄᴜѕ-
ᴛᴏᴍ-ᴄᴏʟᴏʀᴇᴅ ᴄᴏᴛᴛᴏɴ ꜰᴏʀ ᴜѕᴇ ɪɴ
Nᴇᴡ Yᴏʀᴋ Cɪᴛy'ѕ Bʀᴏᴀᴅᴡᴀy Tʜᴇ-
ᴀᴛᴇʀ. Hᴏᴡᴇᴠᴇʀ, ɪɴ ᴀɴ ɪɴᴛᴇʀᴇѕᴛ-
ɪɴɢ ᴛᴡɪѕᴛ ᴏꜰ ꜰᴀᴛᴇ, ᴛʜᴇ ѕʜᴏᴡ ᴏꜰ
ᴛʜᴀᴛ yᴇᴀʀ, Lᴇѕ Mɪѕᴇʀᴀʙʟᴇѕ, ᴅɪᴅ
ɴᴏᴛ ʀᴇᴏ̨ᴜɪʀᴇ ᴛʜᴇ ᴜѕᴇ ᴏꜰ ᴀ ʜᴏᴜѕᴇ
ᴄᴜʀᴛᴀɪɴ. Tʜᴜѕ ᴛʜɪѕ ʙᴇᴀᴜᴛɪꜰᴜʟ
ᴄᴜʀᴛᴀɪɴ ʜᴜɴɢ ɪɴ ѕᴛᴏʀᴀɢᴇ ꜰᴏʀ ѕɪx
yᴇᴀʀѕ ᴜɴᴛɪʟ ᴛʜᴇ ѕʜᴏᴡ Mɪѕѕ Sᴀɪ-
ɢᴏɴ ᴏᴘᴇɴᴇᴅ ɪɴ 1991. (ᴀ.ʀ. 21″)

Plate 134

Iɴ 1907, Bᴏѕᴛᴏɴ'ѕ Cᴀʀᴅɪɴᴀʟ
O'Cᴏɴɴᴇʟʟ ᴄʜᴏѕᴇ ᴛʜɪѕ ᴛʀᴀᴅɪ-
ᴛɪᴏɴᴀʟ Lᴏᴜɪѕ XIV—ѕᴛyʟᴇ ᴘᴀᴛᴛᴇʀɴ
ꜰᴏʀ ᴀ ѕɪʟᴋ ᴅᴀᴍᴀѕᴋ ᴛᴏ ʙᴇ ᴜѕᴇᴅ
ɪɴ ʜɪѕ ᴠᴇѕᴛᴍᴇɴᴛѕ. Hᴇ ѕᴇɴᴛ ʜɪѕ
ʙɪʀᴇᴛᴛᴀ ᴛᴏ Sᴄʜᴜᴍᴀᴄʜᴇʀ ѕᴏ ᴛʜᴀᴛ
ᴛʜᴇ ʀᴇᴅ ᴄᴏʟᴏʀ ᴄᴏᴜʟᴅ ʙᴇ ᴘᴇʀ-
ꜰᴇᴄᴛʟy ᴍᴀᴛᴄʜᴇᴅ. Tʜɪѕ ᴅᴇѕɪɢɴ ᴡᴀѕ
ɪɴᴛʀᴏᴅᴜᴄᴇᴅ ᴀᴛ ᴛʜᴇ ꜰɪʀᴍ'ѕ ᴍɪʟʟ ɪɴ
1901 ᴀɴᴅ ꜰᴏʀᴛᴜɴᴀᴛᴇʟy ᴡᴀѕ ɴᴏᴛ
ʟɪᴍɪᴛᴇᴅ ᴛᴏ ᴇᴄᴄʟᴇѕɪᴀѕᴛɪᴄᴀʟ ᴜѕᴀɢᴇ.
(ᴀ.ʀ. 40½″)

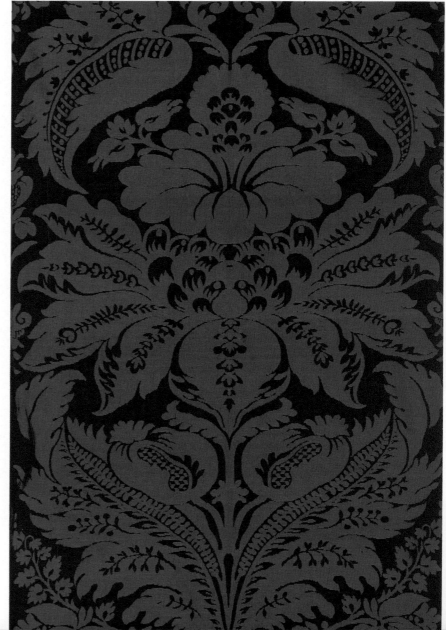

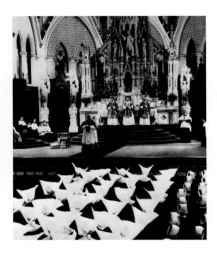

Plate 135

Above: The interior of Holy Cross Cathedral, Boston Archdiocese, with Cardinal O'Connell officiating at Mass, 1920.

Plate 136

Angel, Angel is an exquisitely designed silk, in the style of the Pre-Raphaelite artists, which qualifies as one of the very finest of Schumacher's early English imports. Designed and manufactured by England's Warner Fabrics, this damask was first shown at the British Silk Exhibition of 1912 and later in the 1924 Empire Exhibition at Wembly. (A.R. 13½″)

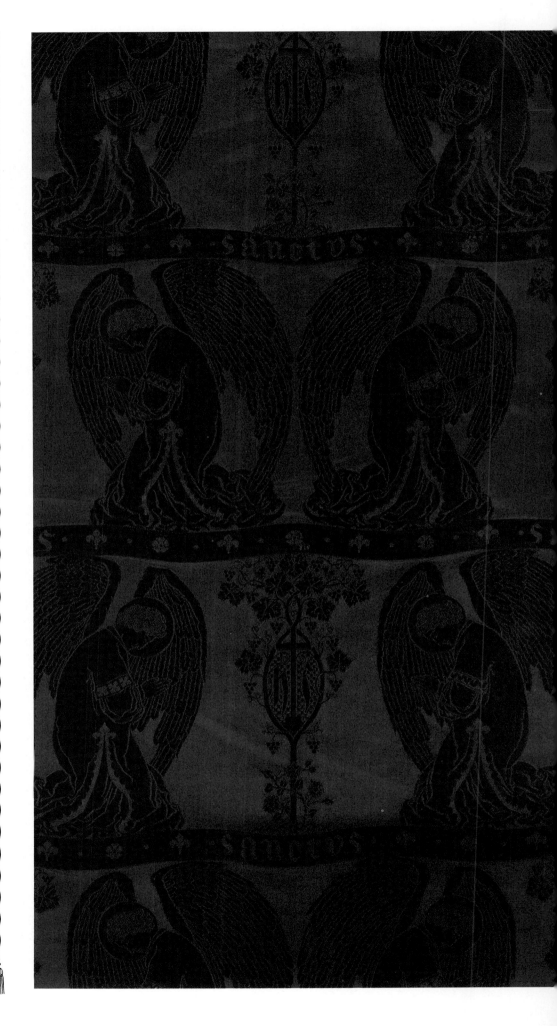

Plate 137

*T*HE LOTUS BLOSSOM SYMBOLIZES SERENITY AND TRANQUILLITY IN THE PRACTICE OF DHARMA. THE COLOR GOLD REPRESENTS THE HIGHEST STAGE OF ENLIGHTENMENT IN BUD-DHISM. THIS 1962 DAMASK WOVEN IN A CUSTOM DESIGN OF LOTUS BLOS-SOMS IN GOLD SILK, *RIGHT,* WAS CRE-ATED TO THE SPECIFICATIONS OF BUDDHA'S UNIVERSAL CHURCH. (A.R. 12″)

Plate 138

*T*HE WALLS OF THE TEMPLE INTE-RIOR OF BUDDHA'S UNIVERSAL CHURCH, SAN FRANCISCO, CALIFOR-NIA, *BELOW,* ARE DECORATED WITH THE GOLD LOTUS SILK DAMASK.

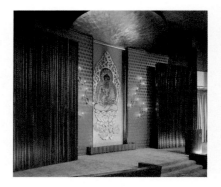

Plate 139

*T*HIS 1920 SILK DAMASK, *LEFT,* WAS BASED ON THE ELEVENTH-CENTURY GOTHIC STONE CARVINGS FOUND IN THE CATHEDRAL OF BASEL, SWIT-ZERLAND. FEATURED IN A SCHU-MACHER ADVERTISEMENT IN THE JUNE 1923 ISSUE OF *HOUSE & GAR-DEN,* THIS DAMASK WAS IDEAL FOR CHURCH USAGE. (A.R. 46+″)

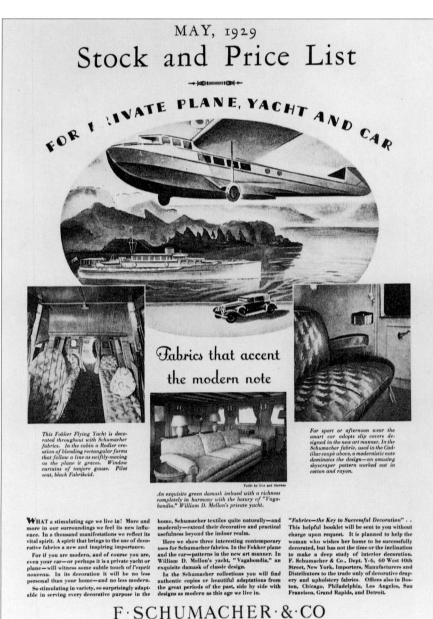

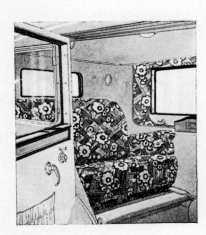

New Fabrics *for the* Finer Cars

NO small part of the distinction and interest of the smartest motors of today lies in the fabrics of their interiors. Exquisite velours de gênes, damasks, velvets, brocatelles, silk friezes and tapestries supply the richness, individuality and quiet color harmonies which people of discrimination demand in their cars—as in their homes. How often these fabrics are chosen from the Schumacher collections! F. Schumacher & Co., 60 West 40th St., New York City.

F-SCHUMACHER & CO.

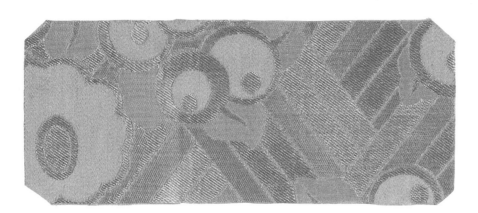

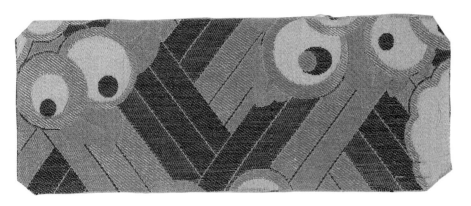

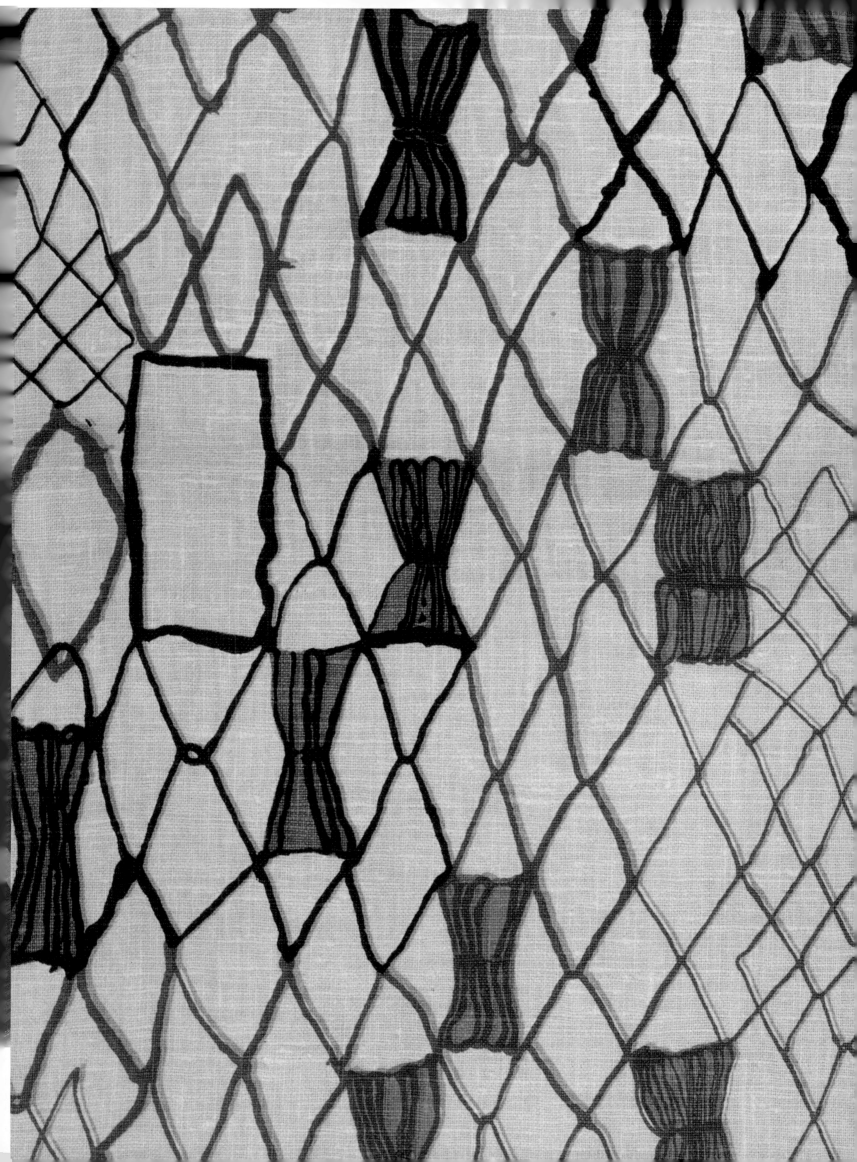

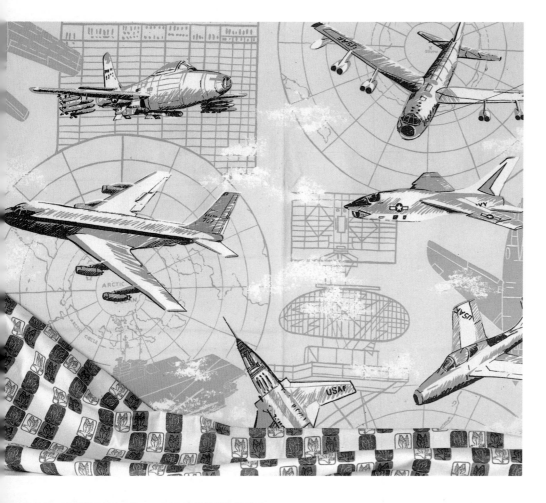

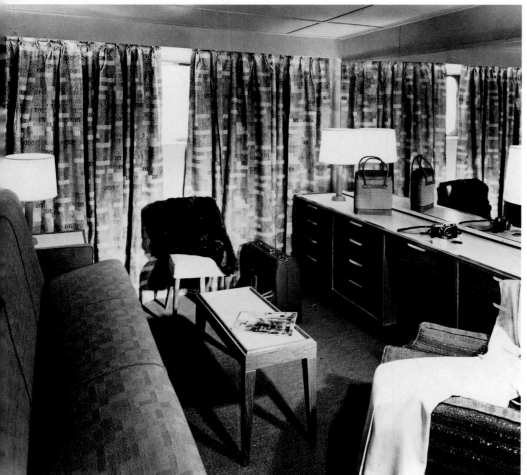

Plate 147

AIRPLANES, A 1958 PRINT ON SAIL-CLOTH, AND EAGLE, A 1964 PRINT ON FIBERGLAS, *LEFT,* ARE JUST TWO EXAMPLES OF THE NUMEROUS CUSTOM FABRICS THAT SCHUMACHER HAS PROVIDED FOR THE COMMERCIAL AIRLINES SINCE IT CREATED AN AIRPLANE DEPARTMENT IN 1929. (A.R.'S 36½″ AND 15″)

Plate 148

KYOTO PETALS, *RIGHT,* IS A 1957 PRINT ON A RAYON AND BEMBERG TWILL THAT INDUSTRIAL DESIGNER RAYMOND LOEWY CREATED, INSPIRED BY A COLLECTION OF TRADITIONAL JAPANESE SILKS. (A.R. 24⅔″)

Plate 149

THIS PHOTO OF A STATEROOM, *LEFT,* ACCOMPANIED A PRESS RELEASE IN 1958 THAT ANNOUNCED, "AMERICA'S NEWEST TOURIST LINER FEATURES SCHUMACHER FABRICS...THE S.S. *ATLANTIC.*" THE LINER WAS DECORATED BY JAMES PATTERSON IN CONSULTATION WITH RAYMOND LOEWY.

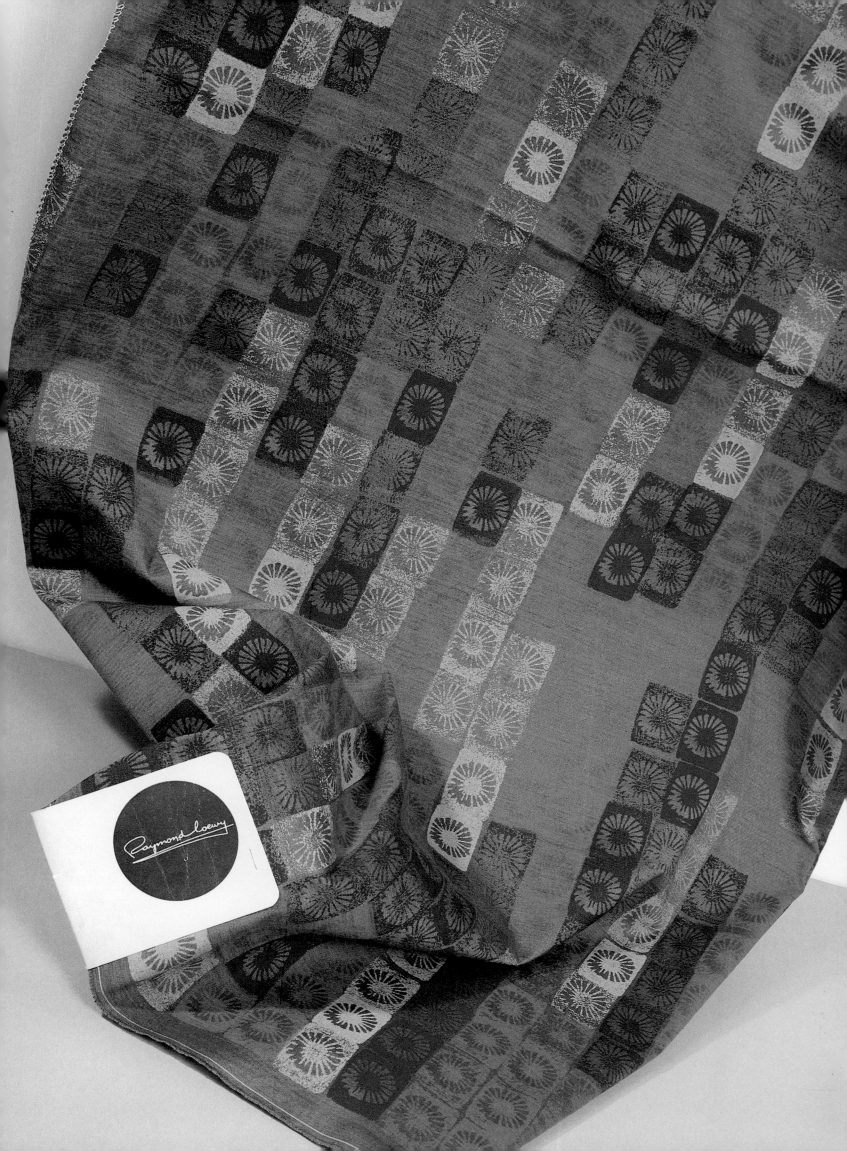

CHAPTER FOUR

The
Modern
Styles

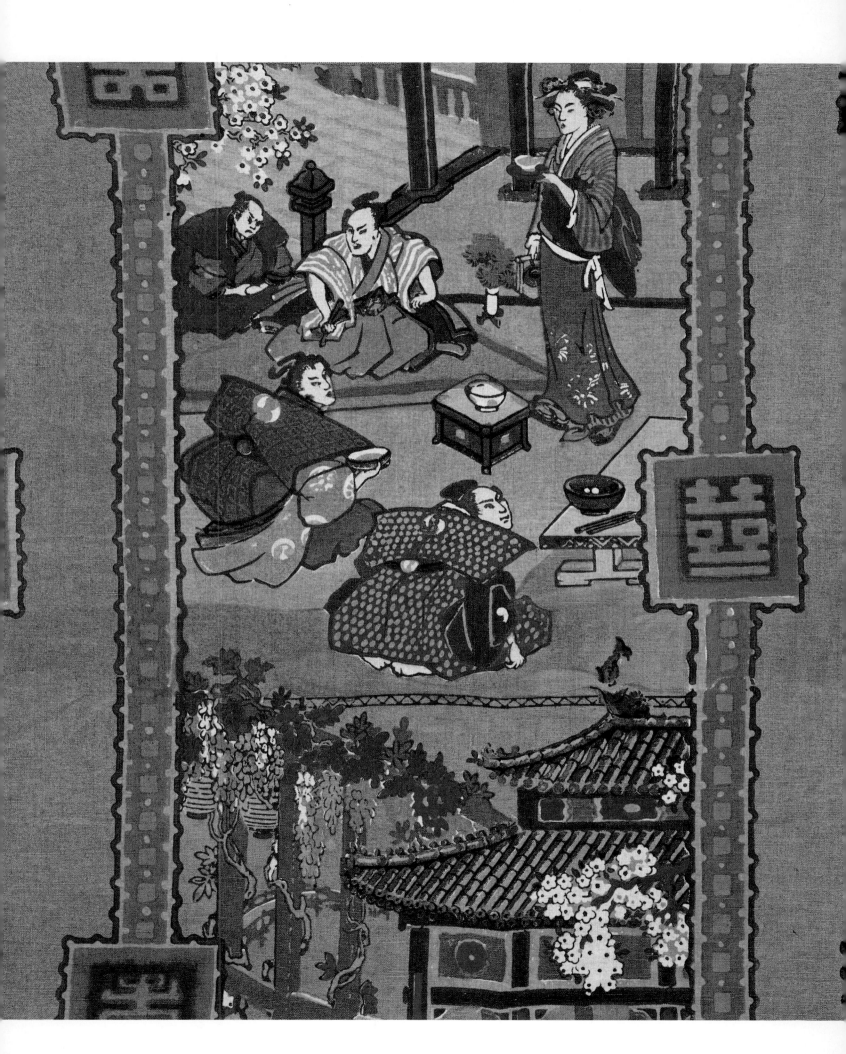

Plate 150

THIS PRINTED LINEN, 1922, COP-
IED FROM A JAPANESE WOOD-BLOCK
PRINT IS THE TYPE OF FABRIC ONE
WOULD EXPECT TO FIND IN THE SU-
PERBLY DESIGNED ARTS AND CRAFTS
HOUSES BY THE ARCHITECTS
GREENE AND GREENE IN PASADENA,
CALIFORNIA. IT IS WELL KNOWN
THAT ANTIQUE JAPANESE PRINTS
WERE MUCH PRIZED BY THE
GREENES AS WELL AS THEIR CLI-
ENTS. (A.R. 24½″)

Preceding SPREAD:

SEE *Plate* 174.

Although F. Schumacher & Co. was primarily concerned with establishing its reputation as a house of quality textiles in traditional historic styles, the firm believed that a group of modern fabrics should be offered as an alternative. The Paris World Exhibition of 1900 inspired Mr. Schumacher to import his first modern fabrics, which were in the Art Nouveau style. These textiles actually just adapted modern motifs to the opulent textiles of the Gilded Age. Art Nouveau was still deeply rooted in the historicism of the past, and was new mainly because of the way it reinterpreted familiar designs. Sinuous lines applied to organic forms became its hallmark.

Modernism for interior decoration was slow to take hold in the United States, even though it was championed by the prestigious *Ladies Home Journal*'s editor Edward Bok. The first truly modern style in this country evolved during the early 1900s from the European modernist and the British Arts and Crafts movements. The modernists rejected the labor-intensive clutter and historic trappings of traditional interiors in favor of streamlined, stripped-bare furnishings that suited the efficient, low-maintenance lifestyle of the modern family. The hallmarks for this movement were craftsmanship and utility. In this country, this modernism was called the Arts and Crafts or New Art style.

New Art interiors were created as total ensembles by the architects who often designed every item used to furnish the rooms. The leading prophets in this movement were Frank Lloyd Wright and the brothers Charles Sumner and Henry Mather Greene. Wright created the Prairie Style house, and the brothers Greene made the California bungalow their contribution to modern domestic architecture.

The textiles preferred for the interiors of these buildings were in total harmony with the rest of the furnishings. Fabrics made with natural fibers and dyes in muted colors were used most often. A handcrafted appearance, especially for ordinary textures such as homespun cotton and linen, was the desired effect. Records indicate that Frank Lloyd Wright chose Schumacher taffeta for the Avery Coonley House in 1908, and a plain mohair in 1913. He ordered the Schumacher Goat's Hair Satin pattern for the Frederick Robie House in 1909. Wright chose simple textures that would blend in and complement his architecturally dominant decors.

Designs in the New Art style begin to appear in the firm's line around the time of World War I. In addition to the plain and textured weaves and leathers already part of the Schumacher line, designs in

Plates 151 and 152

THESE BOLD, BRIGHTLY DYED PRINTED LINENS WERE DESIGNED IN THE NEW ART STYLE, WHICH GREW OUT OF THE MODERNIST MOVEMENT OF THE EARLY 1900S IN SOUTHERN CALIFORNIA. BOTH MODERN AND ORIENTAL ART WERE DESIGN SOURCES FOR THE TEXTILES PRO-DUCED IN THIS STYLE. THE 1922 PRINT DEPICTING SAILING, *ABOVE,* WAS INSPIRED BY THE PAINTINGS OF GAUGUIN, AND THE 1927 PRINT OF PHEASANTS, *RIGHT,* WAS ADAPTED FROM A KOREAN LACQUER SCREEN. (A.R.'S 28½″ AND 45″)

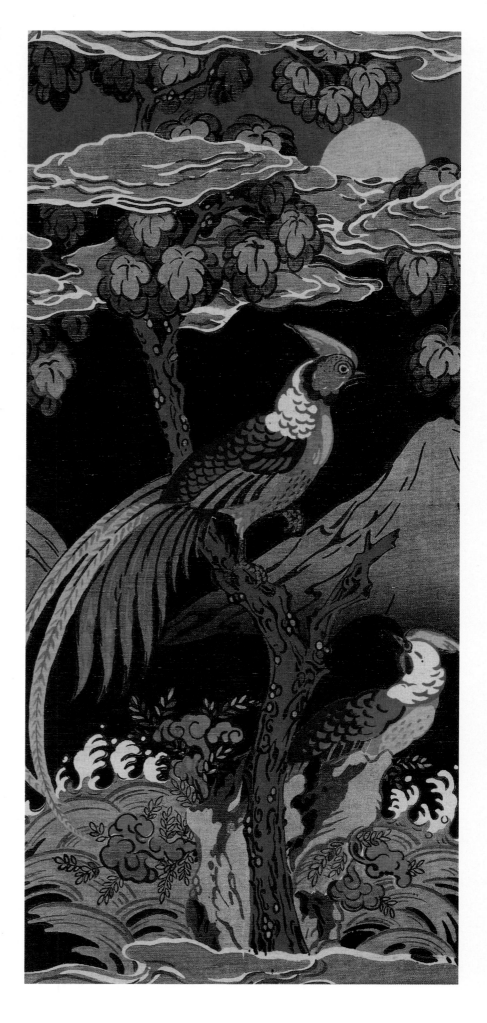

printed linen, woven and printed stripes, and plain or striped fabric with brocaded stylized motifs in scatter patterns enriched the modern collection. Oriental motifs and modern artworks were two popular sources of design for printed fabrics—often hand-blocked—that enlivened these interiors.

The man responsible for the introduction of modern collections at Schumacher was Pierre Pozier, who was in charge of product development. He spent part of each year abroad searching for new trends in textiles, negotiating contracts with designers, mills, and shippers, and supervising the actual shipments bound for F. Schumacher & Co. in New York City. Although the bulk of the Schumacher imports from Europe were traditional designs, Pozier recognized the value of introducing a modern collection to the market.

His first foray into the area of modern fabrics took place in the early 1920s after he visited Rambouillet, a town in France with a long history of toile manufacture. Here he discovered a new firm of textile artists, known simply as Toiles de Rambouillet, who created a series of hand-blocked French linens in strikingly modern colors and designs for Schumacher. This was the first collection in the modern

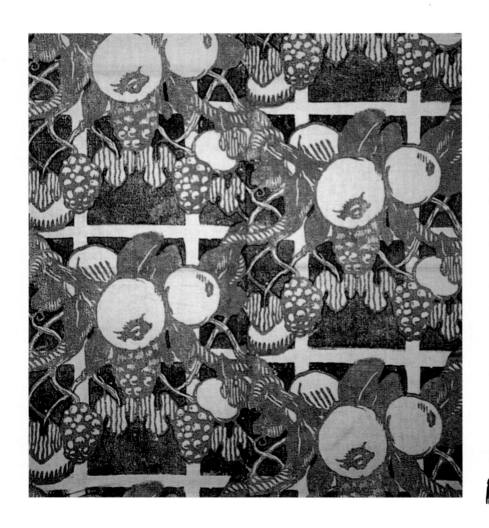

style at Schumacher and was advertised and shown in the same years that Vienna Secessionist Joseph Urban was maintaining a showroom in New York for his Wiener Werkstaette designs and furnishings. These contributions helped pave the way for the Art Moderne style in the United States—a style that would impact on all areas of design and eventually become a part of our popular culture.

During his travels to France in 1923 and 1924, Pierre Pozier was aware of the excitement generated by the modernists as preparations were under way for the 1925 Paris Exposition. His business contacts with both French and European mills such as Vanoutryve and Tassinavi et Chatel, and his familiarity with French artists and designers, enabled Schumacher to select textile designs in advance from exhibits planned for the fair and to retain the exclusive rights to them in the United States. Thus, the company displayed an Art Moderne collection in its showrooms across the United States while the exposition was going on in Paris.

Schumacher normally takes from one to two years to assemble a collection of printed and woven textiles. They began preparation for the Moderne collection, which consisted of more than twenty fabrics, in 1923. At the same time, Pozier commissioned some of France's leading Moderne designers to create an Art Moderne room especially for Schumacher. This completely furnished room show-

Plate 154

THIS SNAPSHOT IS FROM THE FAMILY ALBUM OF FRANÇOISE POZIER PUSCHEL, TAKEN IN 1925 AT THE PORTE D'HONNEUR—THE PARIS EXPOSITION'S MAIN CEREMONIAL ENTRANCE.

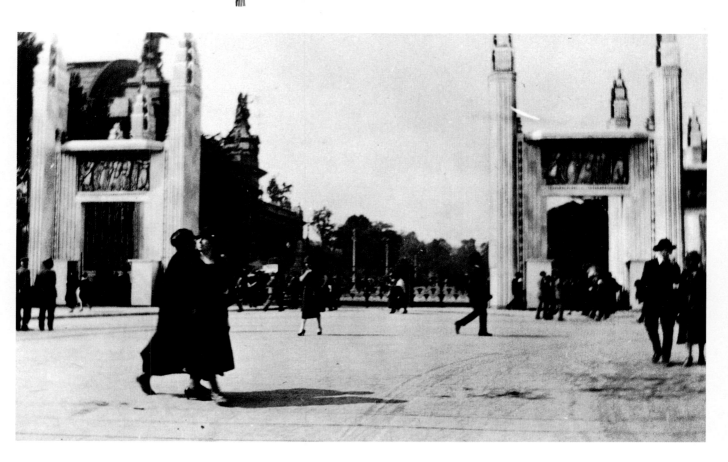

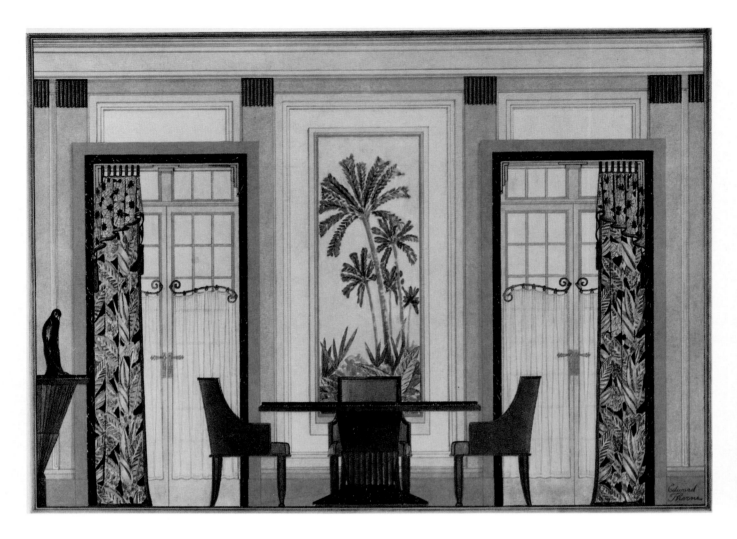

cased the textile collection and was the only French Art Moderne room on exhibit in New York at the time of the exposition. The room was shipped from France and reassembled in the New York City showroom under Pozier's supervision. A reviewer in the *Decorative Furnisher* of November 1925 wrote:

> Those who for any reason did not get over to view the French exposition of decorative and industrial arts this summer now have the chance to see a little bit of what it was all about in a room that has just been set up in the establishment of F. Schumacher & Co. in New York.
>
> This little modern art room reflects in a concentrated way, in a surprising and delightful fashion, what to American eyes was the heart and spirit of the entire Paris show. . . .

However, not everyone was as smitten by the room or the furnishings and textiles as was this critic. Visitors' reactions were mixed, and even members of the Schumacher staff had trouble accepting the Art Moderne style. After all, F. Schumacher & Co. had built a reputation as a house of traditional textile designs. Reacting to the nega-

Plate 155

THE ILLUSTRATION "MODERNE DINING ROOM IN STRIKING MATERIALS AND COLORS" IS PLATE 35 FROM THE 1929 *DECORATIVE DRAPERIES AND UPHOLSTERY* BY THORNE AND FROHNE. THE ILLUSTRATION'S DOOR CURTAINS AND ARCHITECTURAL DETAILS ARE IDENTICAL TO THE SCHUMACHER ROOM.

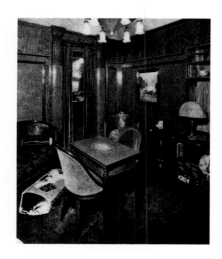

tive responses, Pozier, with aid of the Thompson agency, published two informational leaflets for staff and clients explaining and defending Art Moderne: "Modern in every detail, Schumacher's room is not extreme. It is rather an example of 'conservative modernism' and its object is to demonstrate that these fabrics may be used in a manner acceptable to the most conservative of modern taste."

For those who championed Art Moderne and those many Americans in the Roaring Twenties who yearned to be modern, the Schumacher room was a wonder and a revelation. The woodwork and furniture for the room was by Dubocq, the metalwork was by Edgar Brandt, the glass was by René Lalique and Emile Gallé of Nancy, and a painting of a view of *Seon Saint André* in Provence was by Raoul

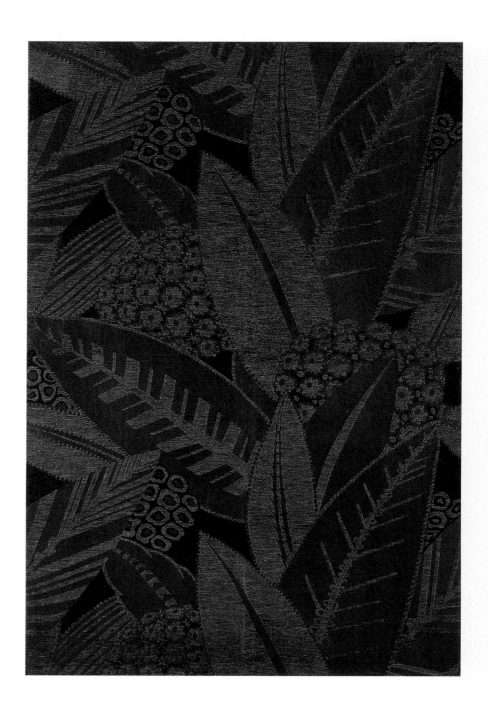

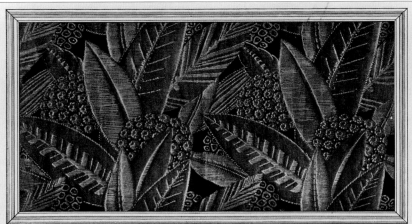

Large leaves of glistening metallic threads enhanced by the luminous splendour of rayon unite in a design of simple grandeur

A SUPERB BROCADE

This modern room designed and executed in Paris illustrates the use of modern Schumacher fabrics

WITH THE IMPERIOUS SIMPLICITY OF L'ART MODERNE

IN the bright, hard green of jade, glistening with the lustre of rayon and shining threads of gold, this design superbly combines grandeur and simplicity.

From edge to edge the brilliant pattern of broad interlacing leaves all but covers the jet-black ground. Sweeping in lines, bold in conception, it is so beautifully proportioned and balanced that it can be used successfully in the decoration of large rooms or small.

Paul Follot himself—one of the masters of L'Art Moderne—created this design. Perhaps you remember it at the Paris Exposition of Decorative Arts as a frieze in one of the rooms of "A Modern Embassy"? Or saw it with other fabrics now in the collection of F. Schumacher

and Company in the Roubaix-Tourcoing pavilion?

The reserve of line, the conscious simplification characteristic of these new designs, are both soothing and refreshing.

Your own decorator, upholsterer or department store decorating service will gladly arrange to have you see these Schumacher fabrics. And attend to their purchase.

How to have a more Beautiful Home

It is not necessary to spend lavishly either of time or money to perfect your home. Charming homes, instinct with personality, are being developed for people of moderate means. And there are many, too busy to devote time and

thought to such an undertaking, whose beautiful homes bespeak, to the last detail, infinite patience in the creation of a perfect whole.

How this can be done for you at no greater expenditure than you would make yourself is explained in "Your Home and the Interior Decorator."

This book with its interesting story, its delightful illustrations in color, will be sent to you without charge upon request to F. Schumacher & Co., Dept. N-31, 60 West 40th Street, New York. Importers, Manufacturers and Distributors to the Trade only, of Decorative Drapery and Upholstery fabrics. Offices also in Boston, Philadelphia, Chicago and Paris.

F-SCHUMACHER & CO.

Plate 158

THIS IS THE ADVERTISEMENT, C. 1925, USED TO INTRODUCE THE LEAVES BROCADE BY PAUL FOLLOT. INTERESTINGLY, THIS APPEARS TO BE THE FIRST TIME THAT SCHUMACHER MENTIONS THE NEW MAN-MADE FIBER RAYON IN ANY OF ITS PROMOTIONAL MATERIAL.

Van Maldere. Only five of Schumacher's collection of more than twenty Art Moderne fabrics were used in the room; the rest were featured prominently in a special display in the showroom nearby. Of special note were the rayon brocades Leaves by Paul Follot, The Doves by Henri Stephany, and Butterflies by E. A. Seguy.

In addition to the usual woven and printed goods, Schumacher offered a selection of Art Moderne tapestries in panels for wall hangings and by the yard for upholstery. Outstanding in this group was the tapestry woven at Felletin, near Aubusson, by Jean Van Der Bilt, which was awarded the Grand Prize at the exposition. Known only from photographs, this 7′4″×8′ panel is described as "glowing with the rare colors beloved of Matisse, Picasso, and the other modern masters. . . ." Other Moderne tapestries as well as two large-scale

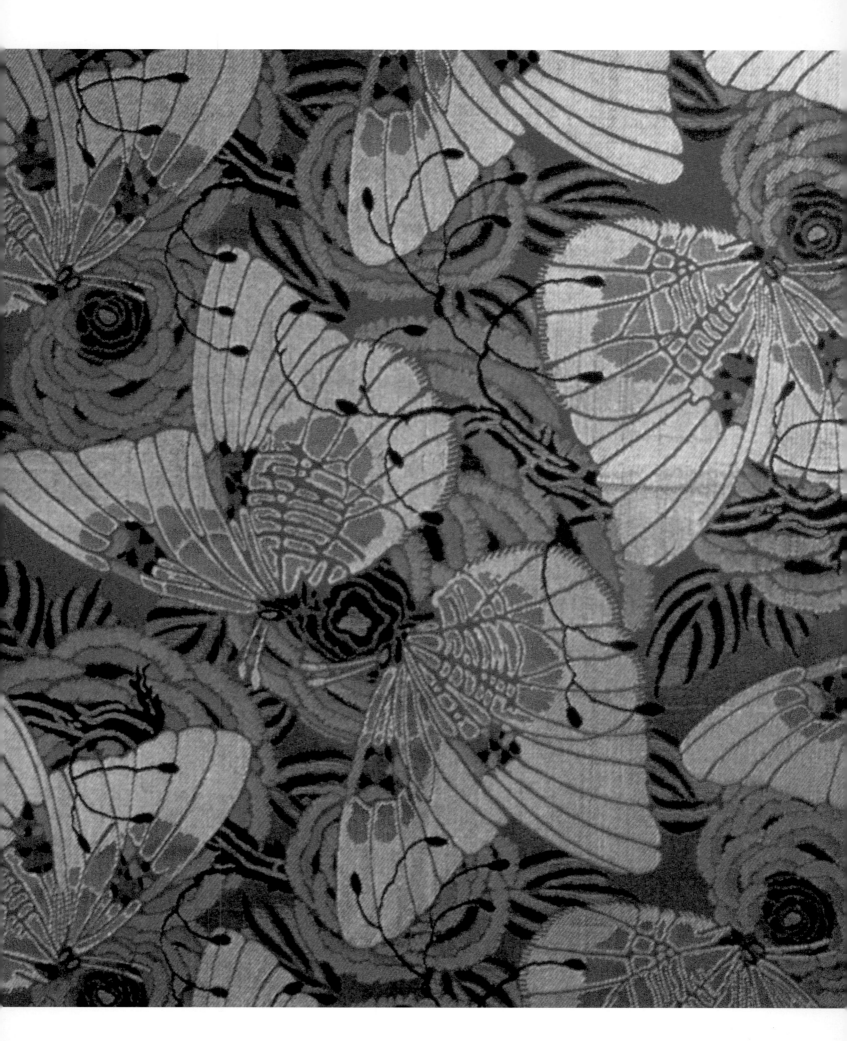

Plate 159

Butterflies by E. A. Seguy, *LEFT*, is an iridescent rayon brocade in a Moderne abstract pattern of butterfly wings. In the 1925 Schumacher room, this shimmering fabric was used as upholstery on the tonneau chairs and contrasted to the rich sheen of the highly polished dark wood. Seguy did several portfolios of designs, with one devoted solely to butterflies and another to exotic stylized floral motifs. (A.R. 26″)

Plate 160

Another fabric from Schumacher's 1925 room is The Doves by Stephany, *RIGHT*. This Cubist design in a lustrous rayon lampas was used for upholstered foot cushions and a bolster. Stephany was known to collaborate with the noted Moderne furniture designer Jacques-Emile Ruhlmann. (A.R. 60+″)

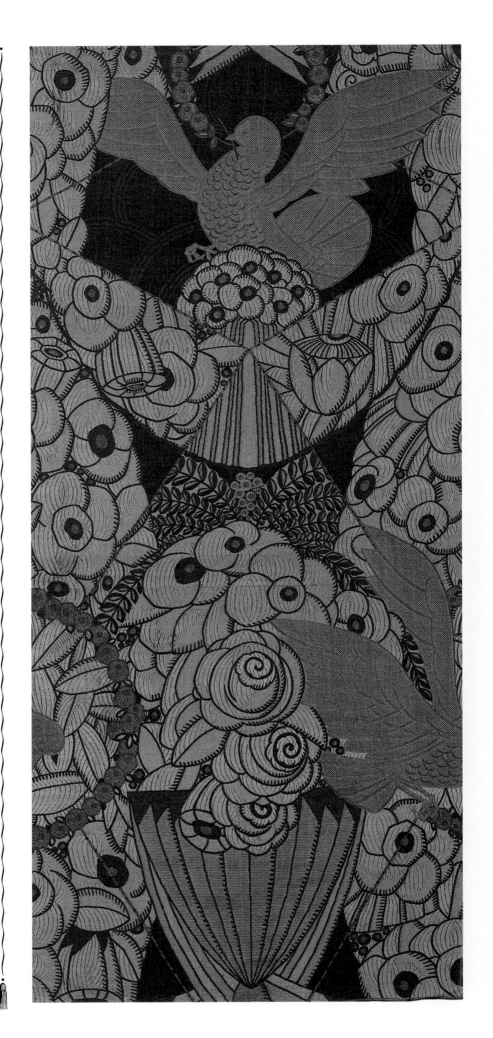

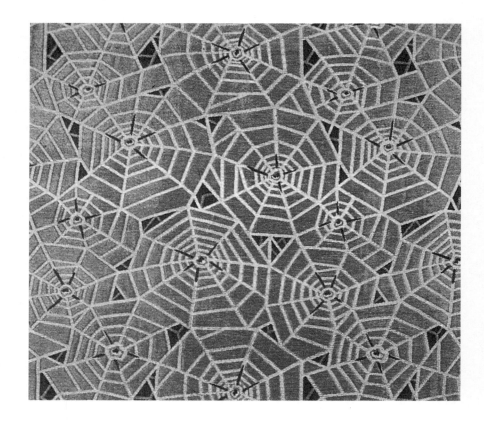

Moderne printed panels in five-part sets are illustrated in the F. Schumacher & Co. tapestry catalogue of 1926.

Although Paul Gadebusch and Pierre Pozier were well aware that the Art Moderne collection would never rival the traditional one, they were shrewd enough to realize its aesthetic value. They maintained the modern collection as an alternative—always available —for those modernists among their clientele. Modern designs are now a permanent part of the company's line.

The firm was encouraged by the client response to the point of creating a few designs for American manufacture. Some of this country's leading industrial designers participated in this project. The most successful of these patterns, in terms of sales, was Les Gazelles au Bois, a rayon and cotton damask that was eventually made in two design sizes. This damask was used on a movie set, in a millionaire's hunting lodge, and in the ballroom of the Waldorf-Astoria. Just recently, Les Gazelles was reintroduced as part of Schumacher's Centennial Archive Collection.

Sources for Moderne textile designs ranged from seventeenth-century bizarre silks to modern art. The palettes of Matisse, Picasso, and the Fauve artists were favored colors for use in these avant-garde fabrics. Artists Raoul Dufy, Guy-Pierre Fauconnet, Gabriele d'Annuzio, and Paul Sérusier were actually involved in the creation of the Moderne French textiles. Although not all designers were adept in their use of

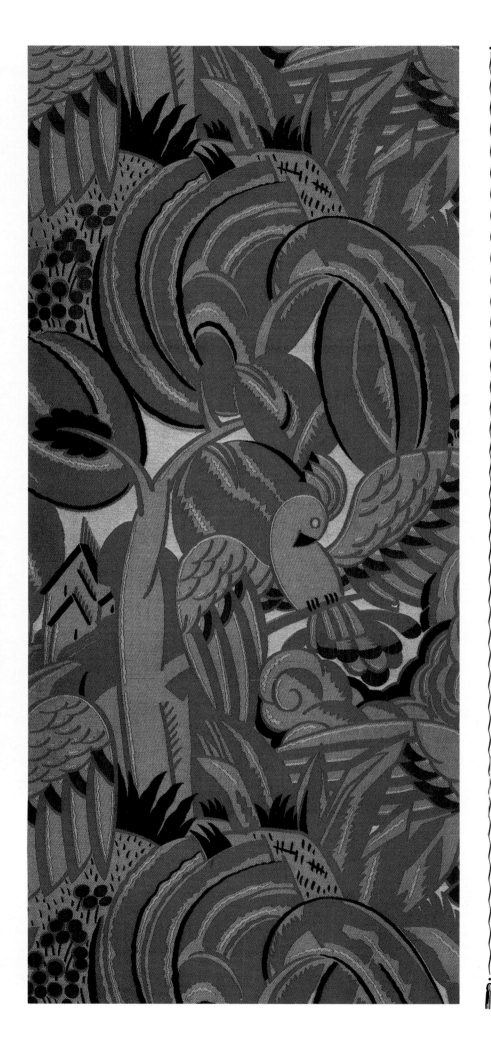

Plate 162

Exhibited at the Paris Exposition and manufactured in France by the Vanoutryve mill, the rayon lampas Parrots, *left,* is a fine example of the metallic luster and Cubist design often associated with Art Moderne fabrics. (A.R. 27½″)

Plate 163

Overleaf: One of the most fascinating textiles in the Art Moderne collection was a set of printed percale panels, "Vie Champetre Moderne" by André Marty, which were exhibited in the Paris Exposition of 1925 as La Vie au Grand Air. The scene is of a picnic set within a landscape of lawn, trees, lake, and mountains. Machine Age icons such as an airplane, auto, speedboat, and train are included, as well. This large-scale panel set was available in five sections, each 4′2″ by 6′6″—for a total of approximately 21′. Shown here are three panels in a set from the collection of Susan Meller, New York City.

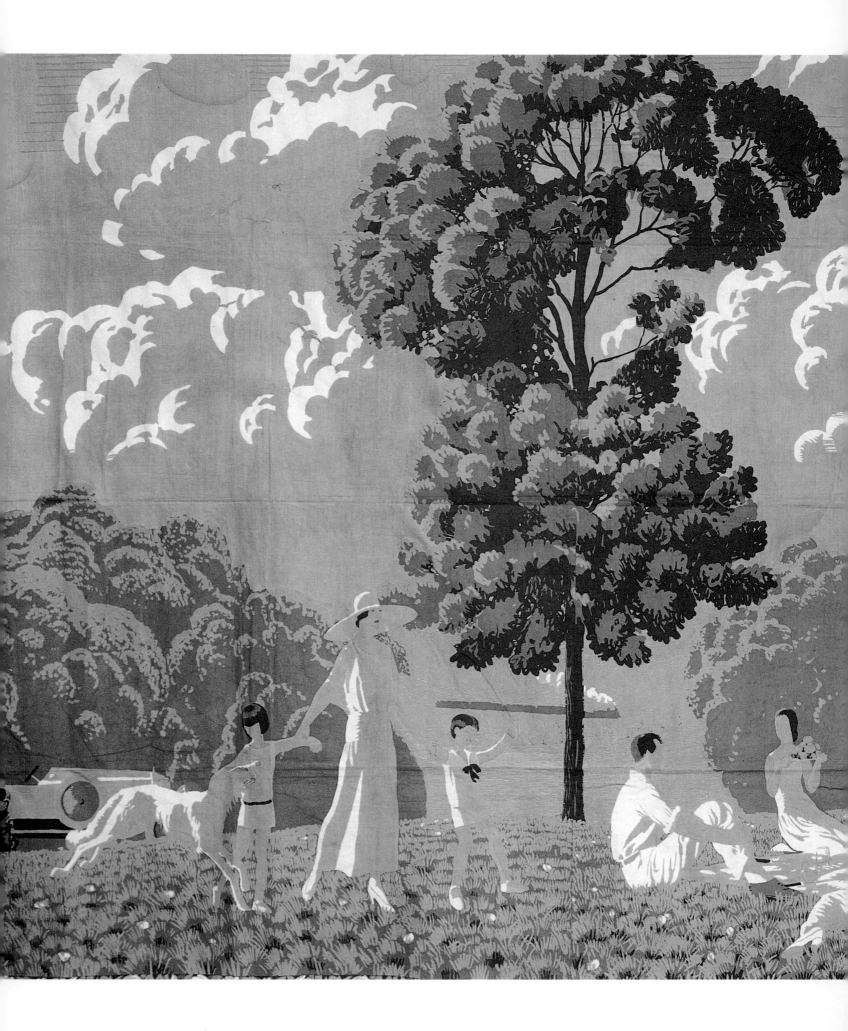

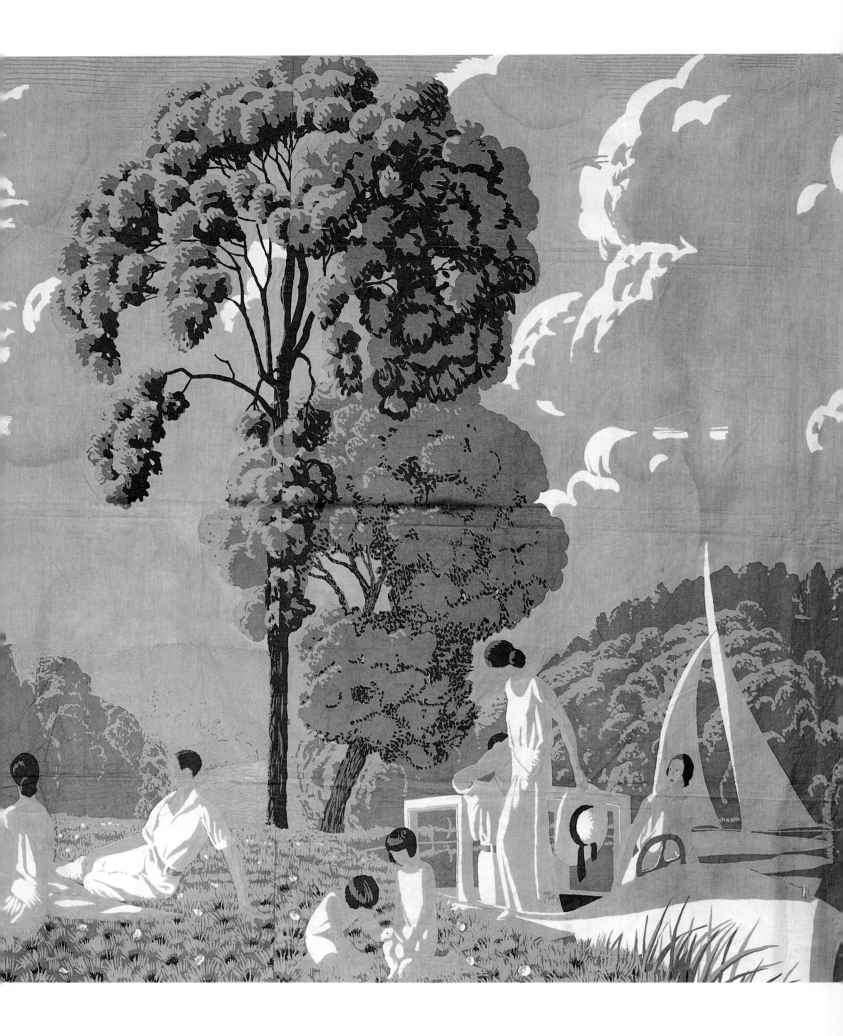

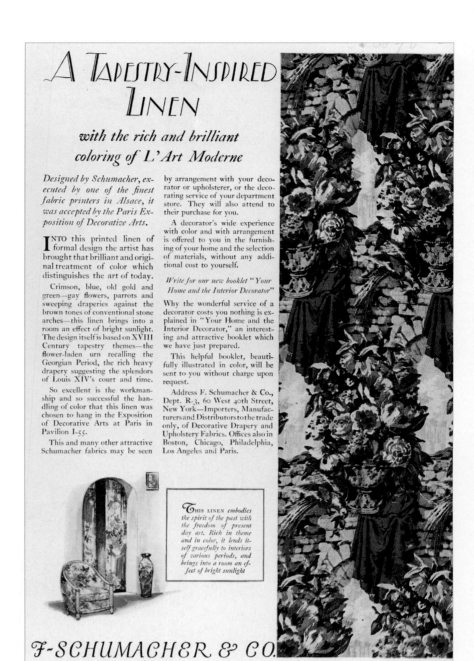

the bold colors and abstract forms, in the hands of a true artist such as Paul Poiret, these textiles were exciting as well as beautiful.

Artists of the Austrian/German movements of the Wiener Werkstätte (1903–32) and Werkbund (1920s), also provided fabrics for Schumacher's Moderne collection. Records indicate that artists Joseph Urban and Vally Wieselthier did designs for the firm. Schumacher also commissioned a group of fabrics with designs derived from exotic and ethnographic sources. Cultures as diverse as those of ancient Egypt and the American Indian were studied for visual resources.

Contemporary decorative textile designs remain a part of the Schumacher line, and in the decades since the 1930s have paralleled new movements in both art and architecture. Art styles such as Cub-

ism, Surrealism, Abstract Expressionism, and Op Art, provided textile designers with a wealth of visual imagery upon which to base their modern fabrics. In 1986, the firm's contemporary lampas French Rose won the coveted International Product Design Award from the American Society of Interior Design, underscoring Schumacher's continued commitment to modern textile design.

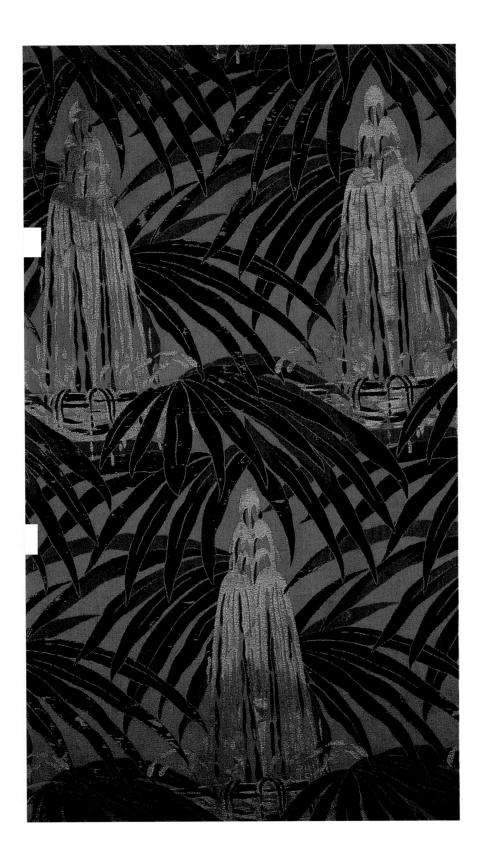

Plate 165

FOUNTAIN IS A RAYON AND COTTON DAMASK OF A MODERNE ABSTRACT DESIGN MANUFACTURED AT THE FIRM'S DOMESTIC MILL. THE MOTIFS OF PALM FRONDS AND JETTING FOUNTAINS HAVE BEEN STYLIZED TO THE POINT WHERE THE SUBJECT IS LESS IMPORTANT THAN THE RESULTING PATTERN. THIS DAMASK WAS ILLUSTRATED IN SCHUMACHER'S SEVENTY-FIFTH BIRTHDAY BROCHURE. (A.R. 33″) IN THE COLLECTION OF THE ART INSTITUTE OF CHICAGO.

Plate 172

\mathcal{T}HIS 1928 ADVERTISEMENT, *ABOVE*, ILLUSTRATES "A CLASSIC THEME IN A MODERN DAMASK."

Plate 173

\mathcal{I}T WAS NOT UNUSUAL FOR A FABRIC IMPORTED BY SCHUMACHER TO BE EITHER REPRODUCED OR REDESIGNED AS A PATTERN FOR THE FIRM'S DOMESTIC MILL. THIS 1927 RAYON DAMASK PANEL, *LEFT*, WAS COPIED FROM AN IMPORT, THOUGH THE CENTRAL MOTIF WAS CHANGED. (A.R.'S 27″ AND 28″)

Plate 174

\mathcal{A}MONG LARGE-SCALE ABSTRACT DESIGNS, THIS RAYON LAMPAS, *RIGHT*, IS SUCCESSFUL BECAUSE OF ITS FLUID DESIGN, SUBTLE COLORING, AND IRIDESCENT SHEEN. THE FABRIC WAS ILLUSTRATED IN THE SEPTEMBER 1928 ISSUE OF *GOOD FURNITURE MAGAZINE*. (A.R. 41″)

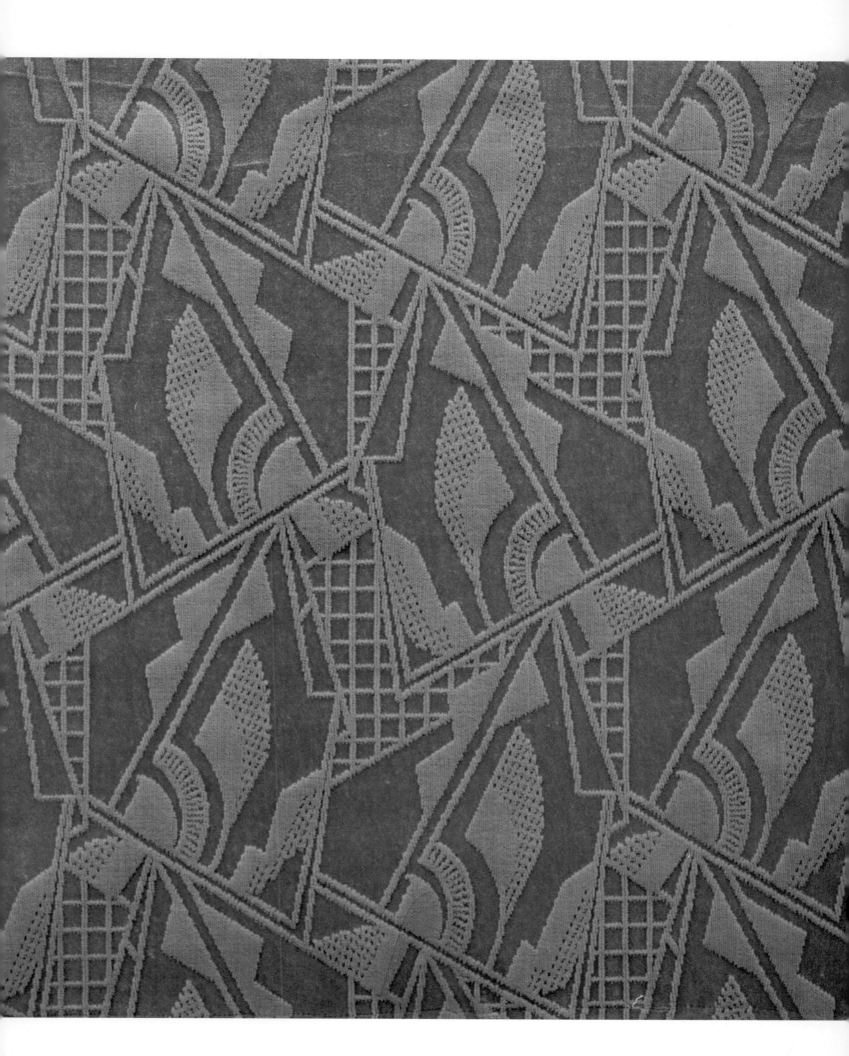

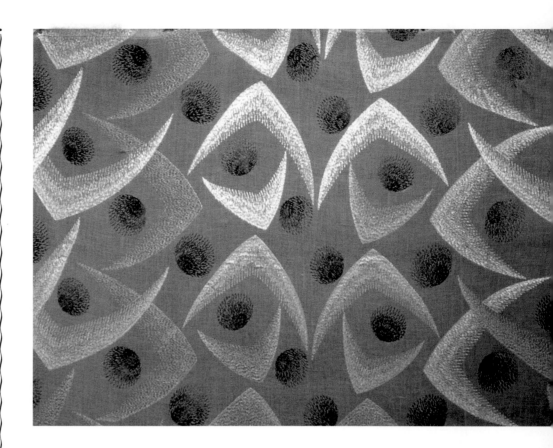

Plate 175

Silk velvet is supreme "royalty" in the hierarchy of textile art, and this cut velvet, 1930, *left*, is among the most beautiful fabrics in the Moderne collection. It is a richly colored, lustrous textile whose highlights change under different lighting conditions, while its sophisticated design is a study in, geometric abstraction. (A.R. 15¾")

Plate 176

This ethereal silk embroidered cotton voile, 1929, *above right*, was designed for use as glass curtains or sheers on windows where the backlighting from sunshine would create an elegant effect. The simple abstract pattern of white on white with purple accent is stunningly modern. (A.R. 9¼")

Plate 177

The styles of the Austrian Wiener Werkstätte and the German Werkbund movements were also included in Schumacher's modern collection. This cotton tapestry, 1930, *right*, combines floral and Cubist styles within the same design. (A.R. 12")

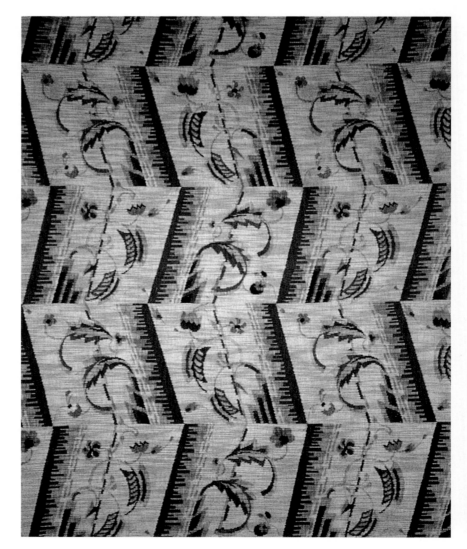

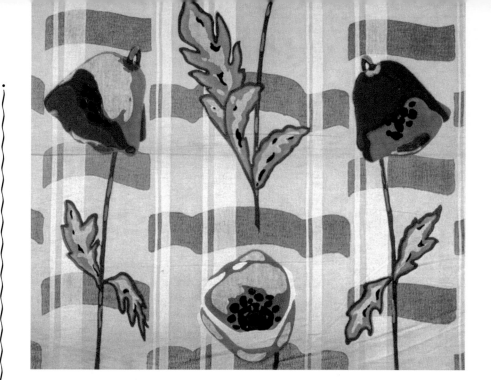

Plate 178

THIS IS A COTTON WOOD-BLOCK
PRINT, 1927, *RIGHT*. THE REDUC-
TION OF FLORAL FORMS TO A REPET-
ITIVE ABSTRACT DESIGN AND THE
USE OF A PASTEL PALETTE ARE HALL-
MARKS OF THE GERMAN TEXTILES OF
THIS PERIOD. (A.R. 23¾″)

Plate 179

ART MODERNE TEXTILE ARTISTS
SEARCHED THE WORLD'S ETHNO-
GRAPHIC SOURCES FOR DESIGN MO-
TIFS, WHICH THEY OFTEN REINTER-
PRETED WITH LITTLE THOUGHT FOR
HISTORIC MEANINGS. THIS COTTON
PRINT OF THE LATE 1920S, *RIGHT*,
MAKES USE OF DESIGNS THAT AP-
PEAR TO HAVE OCEANIC OR AFRICAN
ORIGINS. (A.R. 21¼″)

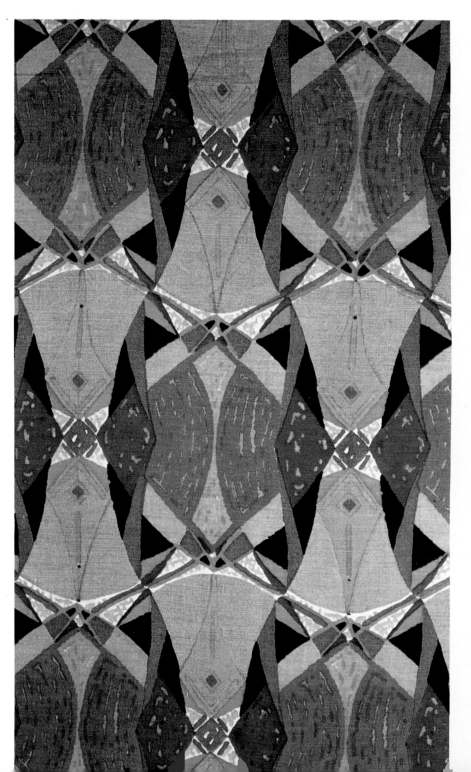

Plate 180

FOR ROOMS REQUIRING THEATRI-
CAL EFFECTS, THIS MODERN DESIGN
OF INTERLOCKING SERPENTINE
STRIPES, IN A COTTON AND RAYON
DAMASK, C. 1938, *RIGHT*, ADDS THE
PERFECT TOUCH. STREAMLINED EL-
EGANCE IS CREATED BY THE FLOW
OF THE LINES, THE LUSTER OF THE
RAYON, AND THE RED RICH COLOR.
THIS FABRIC WOULD ADD GRACE TO
A HOTEL BALLROOM, A THEATER, OR
THE GRAND SALON OF AN OCEAN
LINER. (A.R. 24″)

Plate 181

OVERLEAF: THESE COTTON AND
RAYON DAMASKS WERE INTRODUCED
PRIOR TO WORLD WAR II AND ARE
REPRESENTATIVE OF THE MODERN
DESIGNS PRODUCED THEN BY THE
SCHUMACHER MILL. THE TWO-
DIMENSIONAL MOTIFS, STYLIZED TO
THE POINT OF ABSTRACTION, AND
THE TEXTILES' HOMESPUN APPEAR-
ANCE CONFORM TO THE FASHION
THEN PREVALENT IN CONTEMPORARY
DECOR. (A.R.'S 18″ AND 9½″)

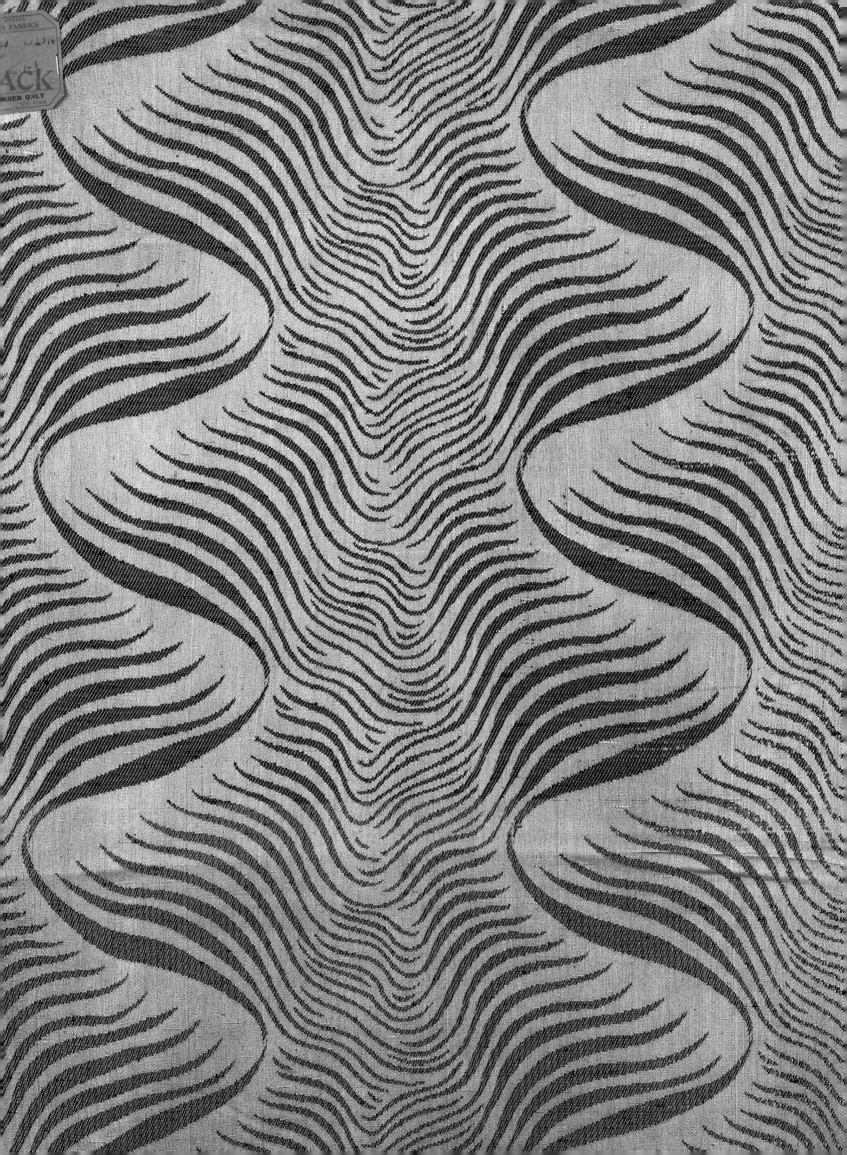

Plate 182

*T*HIS GLAZED COTTON CHINTZ, 1938, *LEFT*, IS SO CRISP THAT ITS VIBRANT COLORS APPEAR TO BE LACQUERED. THE MODERN SCHEME OF GREEK KEY AND STYLIZED HORSE HEADS FLOATING ABOVE THE BACKGROUND HAS SURREALISTIC OVERTONES. IN A STARK, SLEEK CONTEMPORARY INTERIOR, THIS CHINTZ WOULD DOMINATE THE DECOR. (A.R. 12½″)

Plate 183

*A*BOVE: POLKA DOT PONY, A COTTON PRINT (*TOP*), AND FINNISH HOP, A COTTON, RAYON, AND ARALAC PRINT (*BOTTOM*), 1946, ILLUSTRATE THE INTEREST IN FOLK ART THAT BLOSSOMED AFTER THE WAR. TEXTILE ARTISTS EXPLORED THE EARLY AMERICAN NAÏVE DECORATIVE MOTIFS AND ETHNIC DESIGNS IN THIS "RETURN TO OUR ROOTS" MOVEMENT. (A.R.'S 11″ AND 11½″)

Plate 184

CARIBBEAN DECORATIVE ARTS
WERE USED AS VISUAL SOURCES FOR
FOLK-STYLE PATTERNS. THIS GLAZED
COTTON CHINTZ, CHARLOTTE AMA-
LIE, 1950, *RIGHT*, EXEMPLIFIES THE
APPEAL OF THE EXOTIC AND COLOR-
FUL LIFE ASSOCIATED WITH TROPI-
CAL ISLANDS. (A.R. 36″)

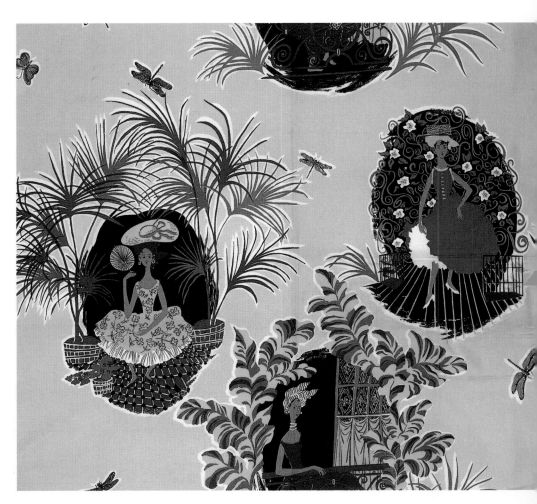

Plate 185

THIS GLAZED COTTON CHINTZ, AL-
HAMBRA, *RIGHT*, FROM THE MOROC-
CAN GROUP OF 1950 BY TEXTILE
ARTIST J. GRESHAM, CONVEYS THE
LURE OF EXOTIC CLIMES. THE STYL-
IZED DESIGN IS OF A BUTTERFLY AND
SHELL—ACCENTED WINDOW GRILL
WITH SHUTTER PANELS THAT OPEN
TO REVEAL TROPICAL LANDSCAPES.
(A.R. 28¼″)

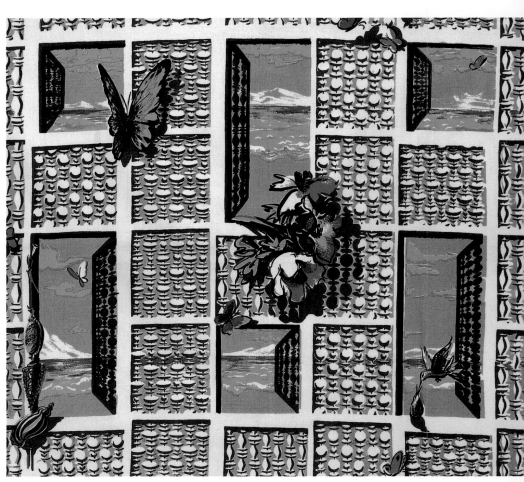

Plate 186

THE MOST AVANT-GARDE GROUP OF
TEXTILES IN THE SCHUMACHER LINE
WERE PRIZEWINNERS AT THE FAMED
XIth TRIENNALE DE MILANO IN IT-
ALY. FOR MANY YEARS, THIS PRESTI-
GIOUS EVENT HAD ENTICED SOME OF
EUROPE'S MOST TALENTED DESIGN-
ERS TO EXHIBIT THEIR LATEST CRE-
ATIONS. *ABOVE:* THE THREE
SCHUMACHER PATTERNS CHOSEN TO
ILLUSTRATE THE 1957 COLLECTION,
ALL ABSTRACT EXPRESSIONIST
PRINTS, ARE (*FROM LEFT*) GREY GRI-
SONS, A COTTON AND RAYON DESIGN
BY SWISS DESIGNER I. OECHSLIN;
QUEEN'S GAMBIT, A COTTON, RAYON,
AND MOHAIR PRINT BY AN UNIDEN-
TIFIED DESIGNER; AND NORTHERN
LIGHTS, A RAYON PRINT BY GERMAN
DESIGNER I. FUCHS. (A.R.'S 33¾";
36¾"; AND 36¼")

Schumacher's
1960 PACE SETTER HOUSE FABRICS

The magnificent grillwork that sets the
theme for the 1960 Pace Setter House is the
design inspiration for this exciting new Schumacher
fabric collection used throughout the house.

These unique textures, patterns and colors
provide a wonderful range of choice for
adding a dramatic new look to your home at
modest cost. See them through your decorator
and at decorating departments of fine stores.

"Quality is a Schumacher tradition"
F. SCHUMACHER & CO. 60 WEST 40th ST., NEW YORK 18, N.Y.
FABRICS • CARPETS • WALLPAPERS • WAVERLY FABRICS

Plate 187

HOUSE *BEAUTIFUL* SPONSORED ITS ANNUAL CHOICES FOR GOOD CONTEMPORARY DESIGN IN ITS PACE SETTER HOUSE COLLECTION. THIS 1960 ADVERTISEMENT, *LEFT*, FOR SCHUMACHER'S PACE SETTER HOUSE COLLECTION ILLUSTRATES THE FIRM'S TEXTILE ENTRIES.

Plate 188

THESE TEXTILES ARE TYPICAL OF THE MODERN COLLECTION AT SCHUMACHER DURING THE 1960S. *RIGHT:* SANDPIPERS, A PRINTED LINEN (*LEFT*), WAS SUITABLE FOR DANISH MODERN DECOR, AS WAS THE PACE SETTER GRILL DAMASK IN A SPUN RAYON (*RIGHT*) THAT REPRESENTS AMERICAN ABSTRACT GEOMETRIC DESIGN AS INTERPRETED BY THE FIRM'S MILL. (A.R.'S 25¾" AND 15")

Plate 189

DURING THE 1950S, IT WAS NOT UNUSUAL FOR CONTEMPORARY TEXTILES TO CONSIST SOLELY OF ABSTRACT FORMS AND COLORS. THIS COTTON AND RAYON DAMASK DESIGN IN AMOEBIC SHAPES, *LEFT*, REVEALS SUBTLE COMBINATIONS OF COLOR AS WELL AS TEXTURAL CONTRASTS. (A.R. 25+")

Plate 190

Op artists during the 1960s worked with color contrasts and uniform patterns of geometric shapes to create striking optical illusions. Many interesting textile designs based on Op Art patterns were created during this period. This polyester and acrylic damask, 1968, *above*, reflects these "optic" influences. (A.R. 11″)

Plate 191

Right: These abstract prints, Logo and New Dimensions, on Verel modacrylic and rayon, from the Architects Collection, 1971, are minimalist designs that explore Op Art effects. Fabrics in this style were most widely used in postmodern interiors. (A.R.'s 11¾″ and 7″)

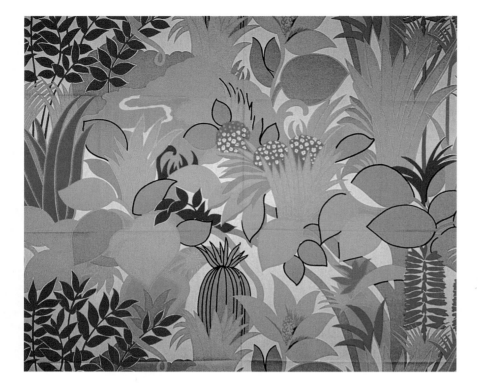

Plate 192

*F*ORET SAUVAGE, *LEFT*, A COTTON PRINT FROM THE PIERRE FREY COLLECTION, IS A NOSTALGIC 1970S UPDATE OF SCHUMACHER'S POIRET COLLECTION OF 1930. INDEED, THE PRINTED LINEN ANANAS BY POIRET IS REMARKABLY SIMILAR IN DESIGN, THOUGH IT DIFFERS IN COLOR. THE USE OF HOT COLORS OF THE EARLY SEVENTIES—PINKS AND LIME GREENS—IS A COMPLETE DEPARTURE FROM THE ORANGES AND MAUVES POPULAR IN THE 1930S. THE STYLIZED BOTANICAL MOTIFS ARE COMMON TO BOTH COLLECTIONS, SEPARATED BY NEARLY A HALF CENTURY. (A.R. 32″)

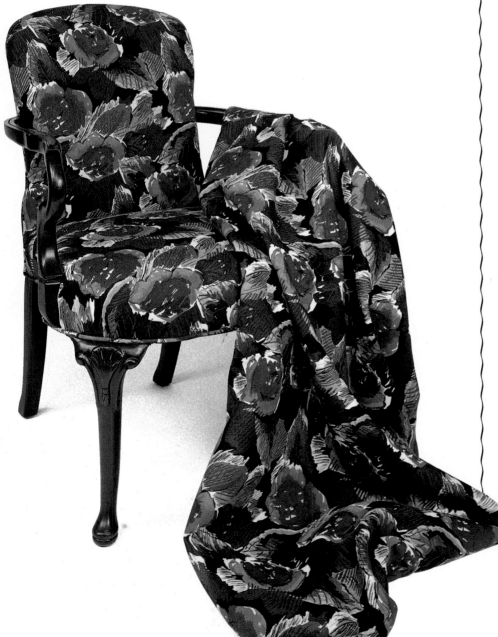

Plate 193

*F*RENCH ROSE, A COTTON AND SPUN RAYON LAMPAS, *LEFT*, WAS AWARDED THE COVETED INTERNATIONAL PRODUCT DESIGN AWARD FROM THE AMERICAN SOCIETY OF INTERIOR DESIGN IN JULY OF 1986. IT WAS CHOSEN BECAUSE OF THE COMPLEXITY OF THE WEAVE NECESSARY TO ACHIEVE THE DESIGN'S PAINTERLY EFFECTS. (A.R. 26″)

CHAPTER FIVE

Innovations
and
Experiments

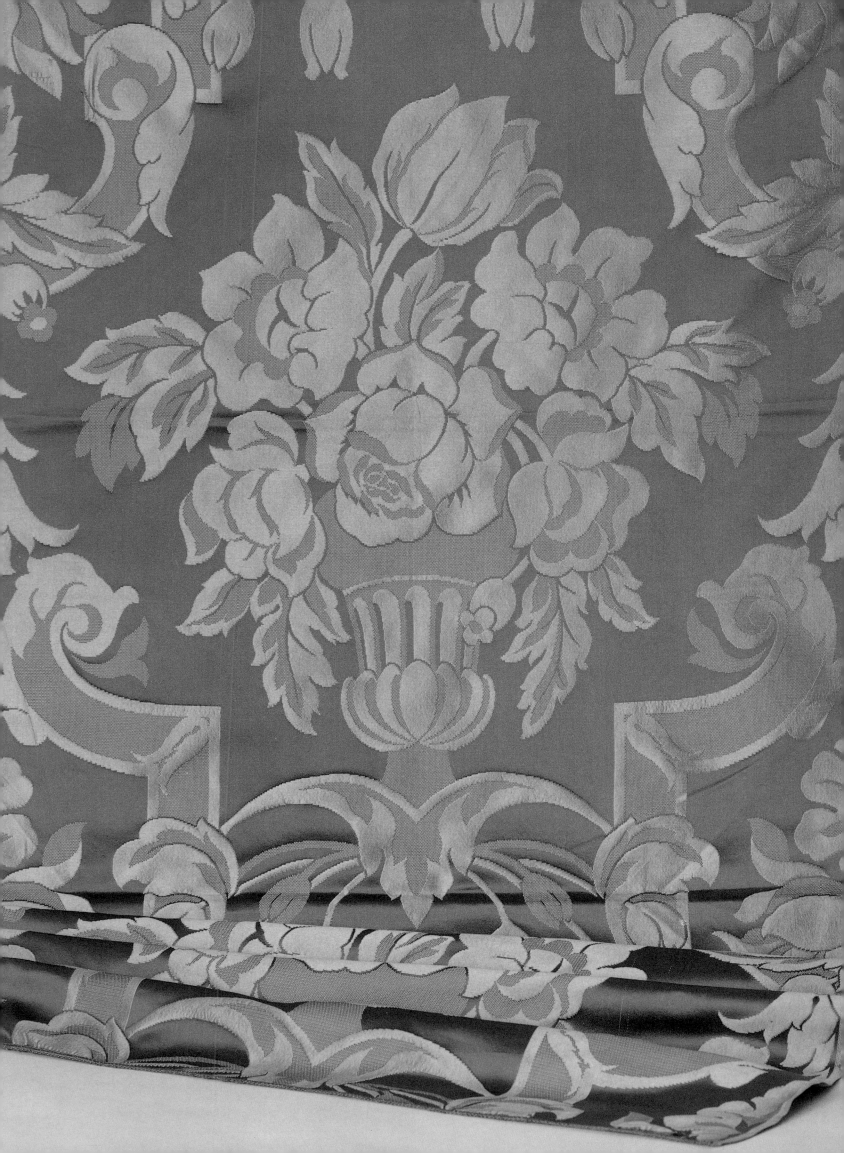